MANET AND THE AMERICAN CIVIL WAR

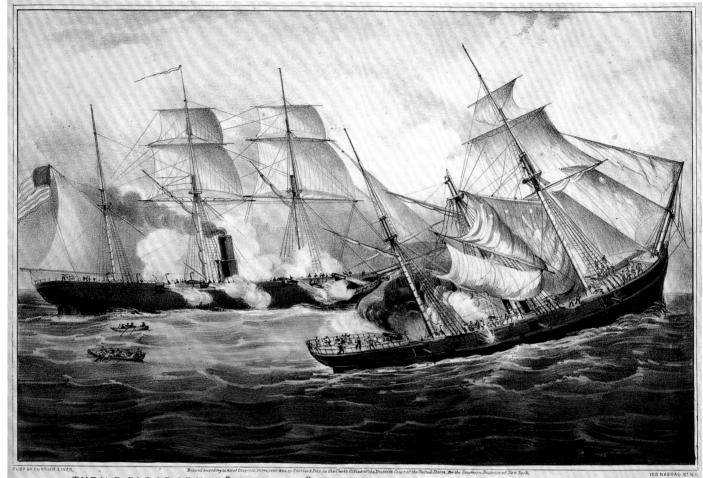

PUBD BY CURRIER & IVES, Entered according to Act of Congress, in the year 1864, by Currier & Ives, in the Clerk's Office of the District Court of the United States, for the Southern District of New York. 152 NASSAU St N.Y.

THE U.S. SLOOP OF WAR "KEARSARGE" 7 GUNS, SINKING THE PIRATE "ALABAMA" 8 GUNS,

Off Cherbourg France, Sunday June 19th 1864.

The "Alabama" was built in a British Ship-yard, by British workmen, with British Oak, armed with British Guns, manned with British Sailors, trained in the British Navy, and was sunk in the British channel, in 80 minutes, by the Yankee Sloop of War "Kearsarge" Capt. John A. Winslow.

MANET

AND THE
American Civil War

The Battle of U.S.S. *Kearsarge*
and C.S.S. *Alabama*

JULIET WILSON-BAREAU WITH DAVID C. DEGENER

The Metropolitan Museum of Art, New York

Yale University Press, New Haven and London

This volume is published in conjunction with the exhibition "Manet and the American Civil War: The Battle of U.S.S. *Kearsarge* and C.S.S. *Alabama*," held at The Metropolitan Museum of Art, New York, from June 3 to August 17, 2003.

This exhibition is made possible by **Prudential Financial**

The exhibition catalogue is made possible in part by the Oceanic Heritage Foundation.

Published by The Metropolitan Museum of Art
John P. O'Neill, Editor in Chief
Dale Tucker, Editor
Tsang Seymour Design, Inc., Designer
Sally VanDevanter, Production Manager

Separations by Professional Graphics, Inc., Rockford, Illinois
Printed by Brizzolis Arte en Gráficas, Madrid
Bound by Encuadernación Ramos, S.A., Madrid
Printing and binding coordinated by
Ediciones El Viso, S.A., Madrid

Front-cover illustration: Detail, *The "Kearsarge" at Boulogne* (fig. 30)
Frontispiece: *The U.S. Sloop of War "Kearsarge" 7 Guns, Sinking the Pirate "Alabama" 8 Guns: Off Cherbourg, France, Sunday, June 19th, 1864*, 1864. Hand-colored lithograph, 16 x 22 in. (40.6 x 55.9 cm). Published by Currier & Ives, New York. Museum of the City of New York, The Harry T. Peters Collection (56.300.435)

Library of Congress Cataloging-in-Publication Data
 Juliet Wilson-Bareau.
 Manet and the American Civil War /
 Juliet Wilson-Bareau with David C. Degener.
 p. cm.
 Exhibition at the Metropolitan Museum of Art
 June 3 to August 17, 2003.
 Includes bibliographical references.
 ISBN 1-58839-079-9 (pbk.)—ISBN 0-300-09962-2 (Yale University Press)
 1. Manet, Edouard, 1832-1883—Exhibitions. 2. Naval battles in art. 3. Ships in art. 4. United States—History—Civil War, 1861-1865—Art and the war. I. Bareau, Juliet Wilson. II. Manet, Edouard, 1832-1883. III. Metropolitan Museum of Art (New York, N.Y.) IV. Title.

ND553.M3A4 2003
759.4—dc21

 2003046466

Contents

DIRECTOR'S FOREWORD

It is only fitting that Édouard Manet's *The "Kearsarge" at Boulogne* (1864) has become a permanent addition to the collection of The Metropolitan Museum of Art. The painting was first brought to the United States in 1898 by two of the Metropolitan's greatest benefactors, Mr. and Mrs. H. O. Havemeyer. When Louisine Havemeyer bequeathed the bulk of her magnificent collection to the Museum, the Manet seascape remained in the Havemeyer family, passing first to the couple's daughter, Adaline Havemeyer Frelinghuysen, and then to Mrs. Frelinghuysen's son, Peter. The family generously placed the painting on long-term loan to the Museum in 1991. Eight years later, an opportunity arose to ensure that the painting would always remain among the nine other Havemeyer Manets at the Metropolitan. Peter H. B. Frelinghuysen, a Trustee Emeritus of the Museum, proposed giving an interest in the picture if donors for the balance could be found. The Museum's trustees rose admirably to the challenge, among them Mrs. Vincent Astor, Mr. and Mrs. Douglas Dillon, Mrs. Charles W. Engelhard, Mrs. Henry J. Heinz II, Mrs. Herbert Irving, and Mr. and Mrs. Henry R. Kravis. The acquisition of the painting was significantly aided by funds made available by the children of Mr. and Mrs. Richard J. Bernhard—Mr. and Mrs. Robert Bernhard and William Bernhard and Catherine Cahill. Additional gifts from Mr. and Mrs. Richard Rodgers and Joanne Toor Cummings, by exchange, completed the arrangement.

We are delighted to have the opportunity to celebrate this acquisition with a dossier exhibition that explores Manet's seascapes of the mid-1860s along with the events that led to his choice of an American warship as subject matter. Rebuffed and ridiculed at the 1864 Salon, Manet set out to earn his colleagues' respect by painting a contemporary event of historic significance. He chose a naval engagement of the American Civil War that had recently been fought off the coast of France, when U.S.S. *Kearsarge* confronted and defeated C.S.S. *Alabama*. Although Manet did not witness the battle, which took place on June 19, 1864, he did visit the victorious *Kearsarge* as it lay at anchor off Boulogne-sur-Mer. The Metropolitan's picture, which shows *Kearsarge* surrounded by numerous smaller vessels, is one of a handful of related seascapes by Manet notable for their bird's-eye perspective and the reduction of sea and sky to flat, flaglike bands of color. It is a pleasure to reunite the so-called *Kearsarge* series of paintings and to juxtapose them with paintings by artists such as Courbet, Monet, and Whistler, who were influenced by Manet's work. It is also particularly instructive to examine *The "Kearsarge" at Boulogne* within the context of contemporary documents, photographs, and prints related to the battle.

The publication accompanying the exhibition is the work of years of research undertaken by Juliet Wilson-Bareau with David C. Degener. They left no stone unturned as they scoured libraries and museums in France and abroad. Recent discoveries made just as the catalogue was going to press include the long-lost register from the Établissement des Bains de Boulogne, dated 1864 and inscribed with the names of the Manet family. The catalogue texts were skillfully edited by Dale Tucker, and our gratitude is also extended to our Editor in Chief, John P. O'Neill. Rebecca Rabinow and Gary Tinterow organized the exhibition, which, as usual, will make visible all that they have learned about the Museum's new acquisition.

The Metropolitan Museum is most grateful for Prudential Securities' support of the exhibition. We are indebted to the Oceanic Heritage Foundation for its important contribution toward the exhibition catalogue.

Philippe de Montebello
Director

SPONSOR'S STATEMENT

In the summer of 1864, in the waters off the coast of Cherbourg, an American Civil War battle engaged the hearts and minds of the French people and inspired a young artist, Édouard Manet, to visually express this compelling contemporary event. His frank rendering of the victorious ship resulted in the innovative painting *The "Kearsarge" at Boulogne.*

Almost a century and a half later, a chapter in the enduring struggle for democracy remains captured on canvas, a testament to the international community's fascination with a growing nation. Prudential Financial was founded in 1875, only eleven years after the battle of U.S.S. *Kearsarge* and C.S.S. *Alabama.* We have grown alongside our country and are proud to bring you a gripping glimpse of its history.

I join my colleagues in celebrating The Metropolitan Museum of Art's acquisition of *The "Kearsarge" at Boulogne.* Through this wonderful dossier exhibition, "Manet and the American Civil War: The Battle of U.S.S. *Kearsarge* and C.S.S. *Alabama,"* we invite you to enjoy the stirring work of Édouard Manet and to reflect on the journey that is America.

John R. Strangfeld
Vice Chairman, Prudential Financial

ACKNOWLEDGMENTS

The "Kearsarge" at Boulogne has piqued the curiosity of many Museum visitors, who wonder why an American battleship anchored off the coast of Boulogne-sur-Mer in 1864 would attract the attention of a young French artist. The acquisition of this painting, long on loan to the Museum, prompted an investigation of the matter. Veteran Manet specialist Juliet Wilson-Bareau and independent scholar David C. Degener rose admirably to the challenge. They ferreted out information for the catalogue as well as objects for loan, along the way raising new, intriguing, and sometimes unanswerable questions. Happily their work on this topic was complemented by their involvement with another exhibition—"Manet and the Sea," opening at the Art Institute of Chicago later this year—which will provide a broader context for this study.

Although modest, this exhibition, like all others, would not be possible without the generosity of lenders, both public institutions and private individuals, some of whom choose to remain anonymous. We thank them all, and for their particular efforts we would like to acknowledge Margaret Brown, Library of Congress, Washington, D.C.; Arthur Lawrence, Union League Club of New York; Anne Witty, Maine Maritime Museum, Bath; and James Zeender, National Archives, Washington, D.C.

It is always a joy to explore the Metropolitan's diverse collections. This exhibition features works from four departments. For their help with their respective loans, we thank Masako Watanabe and Alyson Moss in the Department of Asian Art; Malcolm Daniel, Rachel Becker, and Lisa Hostetler in the Department of Photographs; and Colta Ives and Connie McPhee in the Department of Drawings and Prints. A number of people in the Department of European Paintings were involved with this project in some way, from Kathryn Galitz and Gina Guerra, who ordered photographs for the catalogue, to Gary Kopp, Theresa King-Dickinson, and John McKanna, who hung the pictures. We extend our gratitude to the chairman of the department, Everett Fahy, for his continued support, and further acknowledge Susan Stein, Dorothy Kellett, Patrice Mattia, and Jim Voorhies. Marjorie Shelley, Conservator in Charge of the Sherman Fairchild Center for Works on Paper and Photograph Conservation, helped treat one of the objects in the exhibition, and Martin Bansbach cheerfully assisted us with various instances of matting and framing.

We are also indebted to other colleagues at the Metropolitan. Dale Tucker, who edited the texts, and Sally VanDevanter, who oversaw color corrections, did an admirable job with the catalogue. Michael Langley designed the exhibition galleries, along with Sophia Geronimus, graphic designer for the show. Lisa Cain, registrar, arranged for the safe transportation of all outside loans. We also thank Linda Sylling, Manager for Special Exhibitions and Gallery Installations, for her efforts.

The authors of the catalogue would like to thank the following individuals for their invaluable assistance: Irene Axelrod and Wendy Schnur, Phillips Library, Peabody Essex Museum, Salem, Massachusetts; Christian Biard, Centre d'Archives Historique de la SNCF, Le Mans, France; Robert M. Browning Jr., Historian's Office, U.S. Coast Guard, Washington, D.C.; Norman Delaney, Del Mar College, Corpus Christi, Texas; Michael Hammerson; Glenn Helm, Naval Historical Center, Washington, D.C.; Peggy Haile McPhillips, Norfolk Public Library, Virginia;

Rebecca Livingston, National Archives, Washington, D.C.; Leah Prescott, G.W. Blunt White Library, Mystic Seaport, Connecticut; Ruth Schmutzler, Städelsches Kunstinstitut und Städtisches Galerie, Frankfurt-am-Main; and Mark Tucker, Philadelphia Museum of Art. In Boulogne-sur-Mer, the authors wish to express their gratitude to Frédéric Debussche at the Château-Musée; Karine Jay and her staff at the Bibliothèque Municipale; Karine Berthaud, Archives Municipales; Claude Faye; François Guenoc; Sébastien Hoyer; Xavier Nicostrate; and Claude Seillier. In Cherbourg, thanks are owed to Jacqueline Vastel, Bibliothèque Municipale Jacques Prévert; Roland Jaouen, Capitainerie du Port de Cherbourg; Hilaire Legentil, Service Historique de la Marine; and Gilles Désiré dit Gosset, formerly of the Service Historique de la Marine in Cherbourg and presently at the Archives Départementales de la Manche, Saint-Lô. David Degener would like to add his thanks to Tom Mandel and Beth Joselow, and Gerald Mead and Donna Lach; Juliet Wilson-Bareau wishes to thank Michael and Elke von Brentano, Claudia Oetker, and Margret Stuffmann; both authors are indebted to Claudie Ressort and Bill Scott and would like to extend very special thanks to Rebecca Rabinow and Dale Tucker.

We at the Metropolitan join our director in thanking those individuals who made the acquisition of this painting a reality: Mrs. Vincent Astor, Mr. and Mrs. Douglas Dillon, Mrs. Charles W. Engelhard, Peter H.B. Frelinghuysen, Mrs. Henry J. Heinz II, Mrs. Herbert Irving, and Mr. and Mrs. Henry R. Kravis. We wish to acknowledge those benefactors, now deceased, whose gifts to the Museum were also applied to the purchase— Mr. and Mrs. Richard J. Bernhard, Mr. and Mrs. Richard Rodgers, and Joanne Toor Cummings—and, of course, Mr. and Mrs. H. O. Havemeyer, who brought The "Kearsarge" at Boulogne and other beautiful Manets to New York so many years ago.

Rebecca A. Rabinow
Assistant Research Curator

Gary Tinterow
Engelhard Curator of Nineteenth-Century European Paintings

Manet's Early Experience of the Sea

Compared with other European nations, the French are not a seafaring people. Except for a relative few who live along one of France's coasts, their experience of the sea is often restricted to books, stage spectacles, and images of one kind or another.[1] Édouard Manet (1832–1883) differed from his fellow countrymen in this respect as in many others. He spent 113 days—59 days going, 54 days coming—on a small three-masted sailing ship that under normal conditions transported various raw materials, chiefly coffee, from Brazil to France and assorted European manufactured goods from France to Brazil.

Why did Manet have an experience that so many other Frenchmen did not? Manet's first biographer, Edmond Bazire, finds an explanation in a clash of wills between father and son: "Édouard Manet, who was forced to struggle against the unchanging tastes of his contemporaries, began his life in a struggle against the upper-middle-class ambitions of his parents" (fig. 1).[2] The painter's father, Auguste Manet, evidently expected the oldest of his three sons to follow in his footsteps, which would have meant studying law and settling for a relatively high position in a government bureaucracy. But Édouard had ideas of his own. Bazire continues: "At the age of sixteen, he made up his mind. He was strongly attracted to painting. He had completed his secondary-school studies. He re-

vealed his wishes. He admitted that he had little interest in the law, and he wanted to go to sea. The life seemed to suit him. And it suited his family. Isn't that what really matters in such cases? He was introduced to Mr. Besson, captain of a merchant vessel, and settled into his modest quarters [*poste*] on *Guadeloupe,* a cargo ship headed for Rio de Janeiro."[3]

Manet's story, however, is not that simple. Misunderstanding Bazire's term *poste,* a number of writers have suggested that Manet held some kind of position on board the vessel, *Le Havre et Guadeloupe:* in other words, that he was some kind of naval officer in training. But Manet himself uses the word *poste* many times in the letters that he wrote from *Le Havre et Guadeloupe,* always in the sense "the place where we sleep." Manet was almost seventeen when *Le Havre et Guadeloupe* sailed on December 9, 1848. Indeed, his age was the reason he was on the ship. Manet's social standing—son of a well-to-do and respected magistrate—required him to lead rather than to follow, no matter what profession he elected to pursue. If he wished to spend his life at sea, it could only be as an officer. Entrance to the French naval officers training school—a ship named *Borda* anchored in Brest harbor—was controlled by an examination given once every calendar year and limited to those sixteen years of age or younger. An applicant had only one opportunity to take

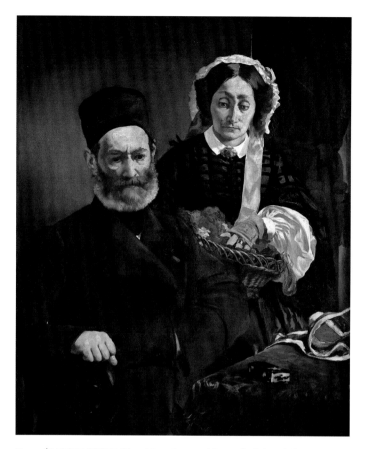

Fig. 1. **ÉDOUARD MANET.** *M. et Mme. Auguste Manet, the Painter's Parents,*
ca. 1860. Oil on canvas, 43 ¼ x 35 ⅜ in. (110 x 90 cm). Musée d'Orsay, Paris

ure made a voyage of any duration that took the candidate across the Equator the equivalent of the twelve months stipulated by the August 9 law.[7]

The names of Manet and forty-seven others were entered on *Le Havre et Guadeloupe*'s muster roll as *novices-pilotins*.[8] *Novice-pilotin* is not an official title; it served only to distinguish the forty-eight paying guests from sailors and shipboys.[9] There was a show of discipline on board. As Manet wrote to his mother, "The officers are *stern,* but they're good guys. In any case we have to behave, because we have to observe the same disciplinary rules as the sailors. Anyone who does anything stupid is placed in irons on the spot. So you can believe we think twice."[10] It seems very unlikely that any of the paying guests were reprimanded for anything or by anyone but the captain or his second. The vessel also embarked four young men as *professeurs;* none of them had any connection with the French navy. The letters that Manet addressed to family and friends from *Le Havre et Guadeloupe* demonstrate that the shipowner's purpose in hiring the *professeurs* was to supply the *novices-pilotins* with drill and practice in the academic skills needed for success on the entrance examination.

A history of the French naval officers training school published the year after Manet's death asserts that the October 10, 1848, law "gave rise to a peculiar sort of business. A shipowner in Le Havre decided to outfit a small ship that would enable young men who had failed the entrance exam to take the requisite cruise across the Equator in comfortable circumstances. The sailing ship embarked not only its young passengers but also a certain number of instructors because in principle the former were to pursue their studies during the crossing. The ship's desti-

the examination; if he failed, he could not take it a second time. Manet had taken the entrance examination in 1848 and failed it.[4] But on July 15, 1848, a law was enacted that extended eligibility for the entrance examination to age eighteen and permitted those who had failed it to take it a second time, provided they spent eighteen months at sea. The law said nothing about the kind of ship on which the would-be candidate was to serve.[5] On August 9, Eugène Cavaignac—a French general and the Second Republic's head of state— signed a new law reducing the length of time at sea to twelve months,[6] and on October 10 he signed yet another law that specified the kind of vessel on which the candidate could serve as belonging either to the French navy or to the French merchant marine. This third meas-

nation was the coast of Brazil. No sooner did it reach Pernambuco or Bahia than it turned round and headed back to France."[11] The volume's anonymous author evidently had men like Mathurin Cor—owner of *Le Havre et Guadeloupe*—in his sights.[12] As we have seen, the ship's roll supports his claim that instructors accompanied the unsuccessful candidates, and some of Manet's correspondence with his mother confirms that conditions on board *Le Havre et Guadeloupe* were unusually comfortable.[13] (Nine of Manet's fellow *novices-pilotins* went on to pass the entrance examination in 1849 and emerged from the school in 1852 as *aspirants de 2ᵉ classe*.)

Several of the instructors on board *Le Havre et Guadeloupe* suffered badly from seasickness, and Manet's classmates apparently did not settle into a regular routine of instruction and study until the crossing was well under way. There does seem to have been some effort to initiate the young men into the practices and habits of naval life. In Rio, where the ship spent slightly more than two months, the candidates were allowed ashore only on Thursdays and Sundays so they could have ample time for study. But the ship had rhythms of its own that distracted the less-focused *novices-pilotins* from their scholastic tasks. Manet confessed to his younger brother Eugène on March 11, 1849: "I don't expect to pass the exam this year. There are even more distractions on board a ship than there are on land."[14]

Most of what we know about Manet's trip to equatorial Brazil comes from the letters he wrote to family and friends. Spontaneous, detailed, and long (in contrast to the adult Manet's correspondence, which is often distressingly laconic), they tell us a good deal about what he saw along the way and how he felt about it. A passing remark in one of the

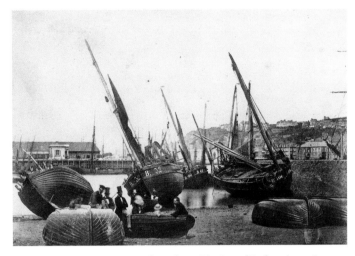

Fig. 2. **UNKNOWN ARTIST.** *Le Port de Boulogne (The Port of Boulogne)*, ca. 1850–53. Salted paper print (Blanquart-Évrard Process) from paper negative. 6 ¼ x 9 ¹/₁₆ in. (15.9 x 23 cm). The Metropolitan Museum of Art, New York, Harris Brisbane Dick Fund, 1946 (46.122.12)

shipboard letters indicates that Manet had already visited the seaside resort of Boulogne (fig. 2) with his family. No doubt he had that experience in mind when writing to his mother in one of the earliest letters: "You do not know the sea if you've never seen it all stirred up the way we have. You cannot imagine the mountains of water that heave up around you and almost cover the ship when they come crashing down or the way the wind whistles through the rigging—sometimes it blows so hard we have to furl all the sails.... We managed to get out of the Channel all right, but adverse winds pushed us back toward Ireland.... There we saw...the sea in all its wrath. So we have gotten pretty used to seeing the sea toss our ship around. It seems months since we left port. The sailor's life is unbelievably boring—always the sky and the sea, always the same thing—stupid, if you ask me."[15]

During the voyage Manet apparently made good use of his artistic talents. Bazire describes the young Manet as an ardent draftsman: "He became very interested in drawing at an early age. An uncle attached to the [Army]

artillery school who spent a lot of his time sketching initiated him into the art. The schoolboy soon fell under the spell of blended lines and blurred cross-hatching. From that moment on, he had only one calling. He neglected his compositions and translations and filled the blank pages of his notebooks not with schoolwork but with portraits, landscapes, and fantasies."[16] The description is ironic considering that Manet's contemporaries would later routinely reproach him for not knowing how to draw. A drawing (now lost) accompanied one of his letters home from the cruise: "At 2 A.M...the man on watch spotted land...we waited for daylight and finally saw Porto Santo Island [one of the Madeira Islands];...it's mountainous, surrounded by rocks, and inhabited only by fishermen.... I made a drawing of it. My drawing will give you a good idea of what it looks like." The young draftsman insists to his mother, "It's a very good likeness."[17] But Manet also turned these skills to social ends: "They couldn't find a drawing instructor in Rio, so the captain asked me to give drawing lessons to my shipmates. So here I am the drawing instructor. I have to tell you that I developed a reputation during the crossing. All the ship's officers and all the instructors asked me to make caricatures of them. Even the captain asked for one, as his Christmas present. Luckily I brought it off to the satisfaction of all."[18]

Bazire writes, a bit hyperbolically, that during the voyage Manet "hardly ever put down his pencil. He sketched the distinctive features of individual faces, then turned them into caricatures. He recorded picturesque details, captured fleeting glimpses. Some very amusing drawings of South America date from this period."[19] Étienne Moreau-Nélaton published a Manet drawing that was believed by its owners to have been made during the Atlantic crossing. The drawing, of a Pierrot, is accomplished: well placed, full of energy, and comparable in quality to the earliest drawings Manet is known to have made in Italy.[20] Another drawing has been advanced as the caricature of Captain Besson mentioned in Manet's letter. The work in question—a stock caricature of the most conventional kind (large head, small body)—is drawn and colored with painstaking care and thus very different from Manet's dynamic manner.[21] Still another work that has recently been connected with Manet's Atlantic crossing—an oil portrait[22]—is said to represent Marie-Paulin Tillet, "an officer on board the ship," but Le Havre et Guadeloupe's muster roll lists no such person.

Although Manet's letters provide some insights into his interests and reactions during the voyage, they do not reveal why he sought admission to the naval officers training school in the first place or why he should have imagined spending his life at sea. There do not seem to have been sailors on either side of Manet's family, so this career choice seems as arbitrary to us as his desire to be a painter seemed to his father. Could he have meant to frighten his father into accepting art as his son's vocation? If that was his intention, it backfired; the senior Manet not only paid the five-hundred-franc fare—a sizable sum—but accompanied his rebellious son to Le Havre and saw him off at the dock. Eric Darragon has argued that Manet invented himself: "By his own remarks, by his behavior, and by the accounts of his past that he allowed to be published, Manet is...responsible for our interpretation of his adolescence."[23] As both Edmond Bazire and Manet's boyhood friend and memorialist, Antonin Proust, tell the story, Le Havre et Guadeloupe is a kind of parenthesis between Manet's expression of his will to

be a painter and his father's eventual acceptance of that decision.

Manet's experience of the sea is not manifestly relevant to his evolution as an artist for the next fifteen years. But in June 1864, under circumstances that we examine in this volume, Manet laid down on a large, almost square piece of canvas his representation of a very recent event: the engagement off France's Normandy coast between two American ships—C.S.S. *Alabama,* a vessel built and outfitted in England by agents of the Confederate States to wage naval guerrilla warfare on merchant ships flying the Stars and Stripes, and U.S.S. *Kearsarge,* a United States Navy vessel sent expressly to eliminate the threat posed by *Alabama* (see fig. 21). The engagement took place on June 19. By July 16, and probably earlier, Alfred Cadart was displaying Manet's painting of the engagement in his gallery and studio at 79, rue Richelieu.

Antonin Proust alleged in 1897 that Manet was in Cherbourg when *Kearsarge* sank *Alabama* and that he observed the conflict from a small boat. But Proust also places the naval engagement in 1865, and in the redaction of his text published in 1913, Proust's editor preserved the claim that Manet observed the engagement directly but removed a reference to his conversations with Manet about Manet's trips to Cherbourg.[24] Other writers either failed to notice the deletion or decided that Proust's inconsistencies and inaccuracies justified further speculation and emendation. The story was retold by writer after writer in the twentieth century, each adding colorful notes in order to outdo his predecessors. The fact remains that not only is there no documentary evidence that Manet was anywhere near Cherbourg on June 19, 1864, let alone bobbing about in Channel waters within earshot and eyesight of the naval contest, there is also no documentary evidence that he ever visited Cherbourg.

France had its own tradition of naval painting, albeit shallow in comparison with those of the Netherlands and Great Britain, perhaps because France's navy was rarely an instrument of French foreign policy. *Combats*—naval engagements—are a standard topos of naval painting. By 1850 works exemplifying this native French tradition in general, and the depiction of naval engagements in particular, were easy to see, especially at the palace in Versailles, which King Louis-Philippe had transformed into a programmatic gallery of French history. The latter years of the July Monarchy also saw a naval art museum installed in part of the Louvre.

One feature of this tradition bears closely on Manet's first sea painting. Naval painters frequently represented engagements that they had not seen because the events had taken place either in the past or in distant waters. Thus French naval painters dealt habitually in imaginations, and their public seems to have been conscious of what in twentieth-century terms was the resulting "inauthenticity." The awareness that such paintings were constructions had no effect on judgments of their value. This disjunction prevailed even when naval artists represented contemporary events. Henri Durand-Brager (1814–1879), a painter who in 1864 was far better known than Manet, produced at least two paintings, two engravings, and one lithograph of the engagement between *Kearsarge* and *Alabama* (see figs. 3, 27). The engravings were published July 2, and the dealer Goupil displayed one of the paintings in his high-end boulevard des Italiens shop no later than July 3, or fifteen days after the conflict. Durand-Brager's contemporaries knew that he was not in Cherbourg on the fateful day, but that

knowledge did not prevent them from hailing his representations for their "amazing accuracy."[25]

It is clear that the imaginative universe in 1864—the complex set of conventions, expectations, and norms under which representations were constructed, circulated, and consumed—was very different from our own. These differences have much to do with technology. Now an assortment of audiovisual venues—primarily television but also film and, increasingly, a variety of electronic and digital media—is the principal source of representations. In 1864 there was no television, radio, or cinema. The printed page—illustrated weeklies, newspapers, prints, and books—was the principal resource for anyone who wanted information or entertainment. A metropolis such as Paris—which Théophile Gautier described without the slightest trace of irony as the "brains of the universe" *(cerveau de l'univers)*[26]—was awash in the visual and intellectual stimulus provided by print. In her influential essay on Manet's sources, Anne Coffin Hanson describes a certain number of these sources as "recognizable…to the French public, [but] not to the present art historian, who finds such references…hidden because of his [or her] lack of familiarity with the world around Manet."[27] That is precisely what we have attempted to do in this volume: that is, to become familiar "with the world around Manet" in 1864. In doing so we were led to examine a vast body of ephemera, including numerous illustrated newspapers and magazines, that are often hard to access because they tend to get thrown away and because few institutions have sizable holdings of them. Where these holdings do exist, the sheer volume of the materials and the heterogeneity of their contents make them difficult to review and assess. These contemporary materials are crucial, however, in our efforts to understand and to judge the works by Manet and the other artists that are presented in this exhibition.

NOTES

1. In a perceptive article on the lessons of the American Civil War for France, King Louis-Philippe's third son, François-Ferdinand-Philippe-Louis-Marie d'Orléans (1818–1900)—the sailor of the family—describes the French as "notably lacking in interest and instinct for the sea" (nous manquons notoirement de goût et d'instinct pour les choses de la mer); "La Marine en France et aux États-Unis en 1865," *Revue des deux mondes* 58 (August 15, 1865), pp. 777–819 (quotation on p. 809).
2. Edmond Bazire, *Manet* (Paris: A. Quantin, 1884), p. 1.
3. Ibid., p. 2.
4. The examination comprised an oral part and a written part and was administered on two different days. In 1848 it was given in Paris on July 5 and 7. It is unclear whether both parts were given on both days or whether each day was reserved for a specific test. For the contents of the test, see "Instruction pour l'admis-sion à l'École Navale. (Concours de 1848)," *Le Moniteur universel,* January 10, 1848, p. 51. Among the numerous requirements, candidates had to "graph the solution to a problem in descriptive geometry and draw a head or a landscape after the model presented to them."
5. *Le Moniteur universel,* July 18, 1848, p. 1683.
6. *Le Moniteur universel,* August 12, 1848, p. 1977. The law still said nothing about the kind of ship.
7. *Le Moniteur universel,* October 11, 1848, p. 2779.
8. The muster roll *(rôle d'équipage)* is preserved in the Archives Départementales de la Seine-Maritime, Rouen.
9. In his *Glossaire nautique,* Augustin Jal defines *novice* as a "young sailor who has little experience of the sea." Augustin Jal, *Glossaire nautique: Répertoire polyglotte de termes de marine anciens et modernes* (Paris: Firmin Didot Frères, 1848), p. 1074. He adds that in

the ship's hierarchy *novice* stands between sailor *(matelot)* and shipboy *(mousse)*. *Pilotin* is defined as "apprentice pilot, helmsman's shipboy" (p. 1174), and, according to Jal, the term is synonymous with *cadet-pilotin,* which he defines as "young man in training as a pilot, student pilot" (p. 378).

10. "Les officiers quoique *sévères* sont très bons enfants; nous avons du reste à nous bien conduire, car nous sommes soumis au même système pénitentiaire que les matelots, ceux qui feraient quelques bêtises seraient immédiatement mis aux fers; on y regarde à deux fois, tu peux le croire." Manet to his mother, Friday, [December 8, 1848], Édouard Manet, *Lettres de jeunesse, 1848–1849: Voyage à Rio* (Paris: Louis Rouart et Fils, 1928), pp. 16–17.

11. *Histoire de l'École Navale et des institutions qui l'ont précédé* (Paris: Maison Quantin, 1889), p. 204.

12. *Le Havre et Guadeloupe* was owned by Cor Palm et Compagnie, Le Havre. Mathurin Cor seems to have been the principal in that firm. Before 1848 the principal destination of *Le Havre et Guadeloupe* was Martinique. In 1855 it became one of seven ships making monthly runs between Le Havre and Havana. Claude Briot and Jacqueline Briot, *Les Clippers français* (Douarnenez: Éditions Le Chasse-Marée/ ArMen, 1993), p. 196. We have not been able to determine whether other shipowners in Le Havre organized similar cruises or whether other ships sailing from Le Havre in 1848 and 1849 carried large numbers of *novices-pilotins.*

13. See Manet, *Lettres,* pp. 11, 16.

14. "Je n'espère pas être reçu cette année, on est encore plus dérangé à bord d'un navire qu'à terre." Manet to his brother Eugène, March 11, 1849, ibid., p. 62.

15. "On ne peut pas se figurer la mer quand on ne l'a pas vue agitée comme nous l'avons vue, on ne se fait pas une idée de ces montagnes d'eau qui vous entourent et qui couvrent tout d'un coup le navire presque tout entier, de ce vent qui fait siffler les cordages et qui est quelquefois tellement fort qu'on est obligé de serrer toutes les voiles.... Notre sortie de la Manche s'est bien effectuée, mais les vents contraires nous ont poussés jusqu'à la hauteur des côtes de l'Irlande.... Là nous avons vu...l'Océan dans toute sa colère, aussi sommes-nous maintenant presque tous habitués à voir notre navire ballotté par les vagues. Il me semble qu'il y a des mois entiers que je suis embarqué; quelle vie monotone que cette vie de marin! Toujours le

ciel et l'eau, toujours la même chose, c'est stupide." Manet to his mother, Friday, December 22, 1848, ibid., pp. 18–19.

16. Bazire, *Manet,* p. 2.

17. "A deux heures du matin...le matelot de vigie a crié terre...on a attendu le jour qui nous a fait voir l'île de *Porto-Santo;*...c'est une île montagneuse, entourée de rochers et habitée seulement par des pêcheurs.... J'ai dessiné l'aspect de l'île. Mon dessin vous en donnera une idée précise. La vue en est très exactement prise." Manet to his mother, Saturday, December 30, 1848, Manet, *Lettres,* p. 33.

18. "On n'a pas pu trouver de maître de dessin à Rio, le Commandant m'a prié de donner des leçons à mes camarades, me voici donc érigé en maître de dessin; il faut te dire que pendant la traversée je m'étais fait une réputation, que tous les officiers et les professeurs m'ont demandé leur caricature et que le Commandant même m'a demandé la sienne pour ses étrennes; j'ai eu le bonheur de m'acquitter du tout de manière à contenter tout le monde." Manet to his mother, undated [Sunday, February 25, or Monday, February 26, 1849], ibid., p. 55.

19. Bazire, *Manet,* pp. 3–4.

20. Étienne Moreau-Nélaton, *Manet raconté par lui-même,* 2 vols. (Paris: Henri Laurens, 1926), vol. 1, p. 14.

21. Gérard Hubert, "Un Dessin inédit de Manet: Le Portrait-Charge du commandant Besson," *Bulletin de la Société de l'Histoire de l'Art Français,* 1994 [pub. 1995], pp. 203–7.

22. Christie's, London, December 8, 1999, lot 6.

23. Eric Darragon, *Manet* (Paris: Fayard, 1989), p. 9.

24. Antonin Proust, "Edouard Manet: Souvenirs," *La Revue blanche* 12 (February 15 and March 15, 1897), p. 174 for the remark about the *Battle* and p. 313 for the remark about Cherbourg. Compare Antonin Proust, *Édouard Manet: Souvenirs,* ed. Auguste Barthélemy (Paris: Henri Laurens, 1913), pp. 53, 118–19.

25. The original phrase—*l'étonnante exactitude*—is from Charles-Olivier Merson, untitled text, *L'Opinion nationale,* July 3, 1864, p. 2.

26. Théophile Gautier, *Tableaux de siège: Paris, 1870–1871,* new ed. (Paris: G. Charpentier et E. Fasquelle, 1895), p. 175.

27. Anne Coffin Hanson, *Manet and the Modern Tradition* (New Haven and London: Yale University Press, 1977), p. 55.

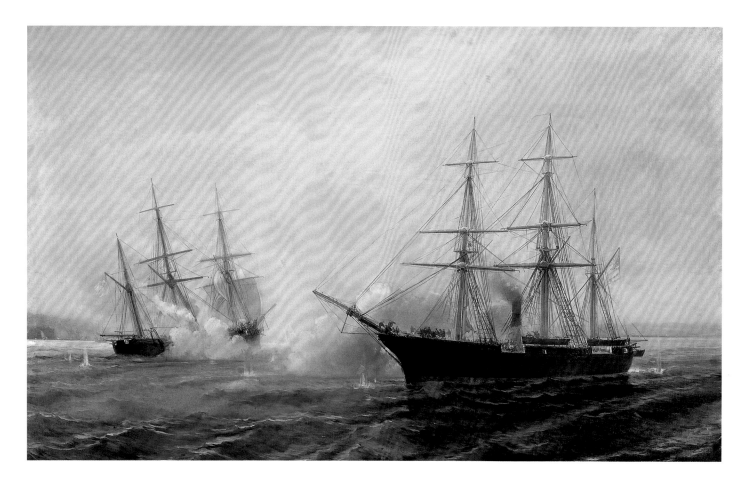

Fig. 3. **HENRI DURAND-BRAGER.** *Battle between U.S.S. "Kearsarge" and C.S.S. "Alabama,"* 1864. Oil on canvas, 40 x 64 in. (101.6 x 162.6 cm). Union League Club of New York

The Naval Engagement

The first shots of the American Civil War were fired at 4:30 A.M. on April 12, 1861, when the armed forces of the Confederate States of America attacked United States Army troops manning Fort Sumter in the harbor of Charleston, South Carolina. U.S. leaders soon realized that the war to preserve the Union had to be fought as much on the economic front as it was in the field. To that end President Abraham Lincoln issued a proclamation on April 15 declaring that a state of insurgency existed in the United States.[1] Four days later, after intense debate within his cabinet, Lincoln announced that it had been "deemed…advisable to set on foot a blockade of the ports within the [seceding] States."[2]

Lincoln's decision to "set on foot a blockade" created a legal quandary. Under international law a nation can close rebellious ports within its own borders, but it can blockade only the ports of another nation. A blockade might thus be construed as a de facto recognition of the Confederate States as independent, and the conflict, by extension, not as a rebellion but as a war. If so, then other nations could recognize the Confederate States as peers, form alliances with them, and aid them in a number of ways.

By acknowledging the American conflict as a war and then declaring themselves neutral, European nations could confer on the Confederate States the status of belligerents, who had standing that rebels did not. According to international law, "[Belligerents] can obtain abroad loans, military and naval materials, and enlist men," unless local law forbids it; "their flag and commissions are acknowledged, their revenue laws are respected, and they acquire a *quasi* political recognition."[3] U.S. Navy Secretary Gideon Welles opposed Lincoln's blockade energetically, calling the conflict "purely domestic—a civil war, and not a foreign war." According to Welles, "a majority" of those present at the cabinet meeting of April 14, 1861, "preferred an embargo…to a blockade…the very fact of a blockade of the whole rebel territory would raise the insurgents to the level of belligerents—a concession to the Confederate organization virtually admitting it to be a quasi government—giving that organization a position among nations that we would not and could not recognize or sanction."[4] But the views of Secretary of State William Henry Seward, who favored a blockade, prevailed, and the next day Lincoln presented the cabinet with a draft proclamation declaring a blockade of the states south of North Carolina. The United States "would have to resign themselves to the certainty that the European powers would accord belligerency status to the Confederacy. But in return they could reasonably expect these same powers to

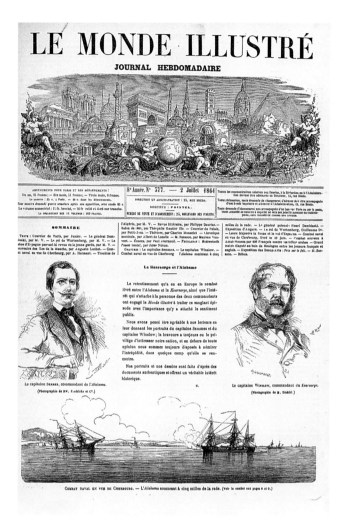

Fig. 4. Front page of *Le Monde illustré*, July 2, 1864. Illustrated are Raphael Semmes, captain of C.S.S. *Alabama,* John Ancrum Winslow, captain of U.S.S. *Kearsarge,* and a depiction of the sinking *Alabama.* The New York Public Library, Astor, Lenox and Tilden Foundations

The economy of the Confederate States was agricultural and its chief products were raw materials, namely, cotton and tobacco. The Confederacy lacked manufacturing capacity for capital goods, and its infrastructure was mostly limited to the structures and facilities needed to support intensive agriculture. Confederate landowners, wholesalers, and traders depended in large part on others—citizens of the United States and foreign nations—to remove the raw materials they produced and to deliver the manufactured goods and raw materials they needed. Many in the seceding states believed that this dependence was right and good. As one Alabama newspaper boasted, "That the North does our trading and manufacturing mostly is true, and we are willing that they should. Ours is an agricultural people, and God grant that we may continue so. We never want to see it otherwise. It is the freest, happiest, most independent, and, with us, the most powerful condition on earth."[6]

Confederate leaders were considerably less confident than the newspaper writers that their material dependence was an advantage. As U.S. Navy Secretary Gideon Welles observed more than once, the Confederate States had neither a merchant marine nor a navy. To remedy that situation the provisional Confederate Congress formed a committee on naval affairs, and its chair, C. M. Conrad, sent telegrams to native or adoptive "sons" of the seceded states whom he deemed "versed in naval affairs."[7]

One of these "sons" was Raphael Semmes (1809–1877). A U.S. Navy man since 1826, Semmes had seen action in the war that the United States undertook against Mexico in 1846, when the ship under his command,

proclaim their neutrality in accordance with international law."[5] On May 13, 1861, Queen Victoria of Great Britain issued just such a proclamation of neutrality, and on June 11 Emperor Napoleon III of France issued his. The evolving rules and policies of neutrality would eventually play a large role in determining the circumstances under which, in June 1864, U.S.S. *Kearsarge*—a ship originally built to enforce Lincoln's blockade—engaged and sank the Confederate raider *Alabama* off the coast of France in one of the most celebrated naval battles of the American Civil War.

U.S.S. *Somers,* sank while blockading Vera Cruz. He had been chasing a vessel that he mistakenly believed to be a blockade-runner; instead it was U.S.S. *John Adams,* the ship sent to relieve him. During the chase, as Semmes later recalled, "I was struck by a heavy norther [a strong wind], and capsized and sunk in *ten minutes;* losing about one half my crew, which consisted of seventy-six persons, all told!"[8] This mishap had no effect on Semmes's navy career. In 1858, he was appointed secretary of the navy's Lighthouse Board and moved to Washington, D.C.[9]

After his adopted home state of Alabama seceded, Semmes, who had already "made up [his] mind to retire from the Federal service, at the proper moment,"[10] resigned his position on February 14, 1861, when he received Conrad's telegram inviting him to Montgomery "at [his] earliest convenience."[11] There Semmes met with Jefferson Davis, provisional president of the Confederacy, who ordered him back to the United States to purchase arms and ammunition.[12] Semmes tells us that although he was initially successful, as March wore on the businessmen with whom he dealt "were becoming more shy of making arrangements with me."[13]

Assigned to the Confederate States Lighthouse Board, Semmes insisted on having a sea command. The Confederacy, however, still had virtually no ships. The Confederate navy secretary showed him reports from a group of naval officers sent to New Orleans to buy "light and fast steamers to let loose against the enemy's commercial marine." The officers found ships, but they also "found some defects in all of them." One report described "a small propeller steamer, of five hundred tons burden, sea-going, with a low-pressure engine, sound, and capable of being so strengthened as to be enabled to carry an ordinary battery of

four, or five guns."[14] They were instructed to purchase the ship, and the next day Semmes was given command of the new steamer, provocatively named *Sumter.*[15] After refitting the ship in New Orleans, Semmes sailed on the evening of June 18. It took him twelve days to negotiate the ninety-odd miles separating New Orleans from the Gulf of Mexico and to elude the U.S. Navy ships blockading the mouth of the Mississippi.

Between July 3 and 27, 1861, Semmes, in command of C.S.S. *Sumter,* captured ten merchant vessels flying the Stars and Stripes. He burned one; the crews of two others regained control of their vessels; the governor general of Cuba ordered another six to be released; and Semmes ransomed the tenth— that is, he forced its captain to sign a document promising to pay the president of the Confederate States a certain sum of money when the war was over. Between September 25, 1861, and January 18, 1862, Semmes captured another eight merchant vessels, ransoming two and burning the rest.

Sumter docked in Gibraltar on January 18. Although feted by Gibraltar's British rulers, Semmes was stymied in his efforts to repair *Sumter,* and, thanks in part to the efforts of Horatio Sprague, U.S. consul in Gibraltar, he was unable even to buy coal. On February 12, U.S.S. *Tuscarora* took up station at Algeciras, a Spanish port approximately five and a half miles west of Gibraltar, from which vantage point its officers and crew could keep an eye on Semmes, and on March 8 U.S.S. *Kearsarge* sailed into Gibraltar's harbor. Two days later *Kearsarge* removed to international waters, where on March 13 it was joined by U.S.S. *Ino.* On orders from John Murray Mason, Confederate States commissioner (diplomatic representative) to Great Britain, Semmes did nothing. Mason authorized

Semmes to pay off his remaining crew (forty-six men had deserted since New Orleans), and on April 14 Semmes and several officers sailed for Southampton on a British mail steamer. "It being evident that there was nothing available for me," Semmes recalled in his memoirs, "I determined to lose no time in returning to the Confederacy."[16] It would not be long before he was given a new command: a cruiser, built in Liverpool, whose launch would incite an intense political intrigue.

THE LAUNCHING OF C.S.S. *ALABAMA*

The new cruiser was the work of James Dunwoody Bulloch (1823–1901), a native of Georgia and a former U.S. Navy lieutenant. He had been ordered to Great Britain "for the purpose of purchasing or having built…six steam propellors," meaning six screw steamers. "The class of vessels desired for immediate use is that which offers the greatest chances of success against the enemy's commerce…." They did not have to be large, but they did have to have "speed and power," and they were to be armed with "one or two heavy pivot guns and two or more broadside guns."[17] Queen Victoria's declaration of neutrality of May 1861 had reiterated the terms of a law dating to the reign of George III and commonly known as the Foreign Enlistment Act, which prohibited the outfitting of, or aid to, vessels that would be used to commit hostilities against a nation with which England was not currently at war.[18] For the next two years, however, British customs agents, port authorities, prosecutors, judges, and courts found ways of understanding the law and the Queen's declaration that excused Bulloch's operations.[19] Nevertheless, it was with some circumspection that Bulloch signed a contract first with the Liverpool firm of William C. Miller and Sons—for a screw steamer that would come to

be known as C.S.S. *Florida*—then with the Birkenhead firm of John Laird Sons and Company for a vessel known during its construction and for the first few weeks after its launching as *No. 290*, it being the 290th ship built by the yard.

Despite the efforts of U.S. government spies, detectives, insider informants, and turncoats, *No. 290* sailed from Liverpool on July 29, 1862, under the name *Enrica* on what was ostensibly no more than a trial run. As cover *Enrica* embarked a small party of guests, but the ship's commander, Matthew J. Butcher, put them and Bulloch ashore in Moelfra Bay, on the coast of Wales. The next day Bulloch rejoined the ship in a tug carrying supplies and a crew. Butcher then dropped Bulloch on the Irish coast and proceeded to his rendezvous with Semmes, who was in Nassau when the order to command *No. 290* caught up with him. *Agrippina*, a commercial vessel that Bulloch had bought for the purpose, was to meet Butcher with the ship's guns.[20]

The rendezvous took place at Terceira Island in the Azores. Semmes arrived in *Bahama*, a commercial vessel, on the morning of August 20 and had Butcher sail *Agrippina* round to Angra, on the south side of the island, where *No. 290* began loading its guns and ammunition. On August 24, 1862, Semmes commissioned the ship C.S.S. *Alabama*, ran up the Confederate States flag, and "released [the pickup crew] from the contracts under which they had come thus far." Any who "preferred to return to England could do so in the *Bahama*," but he urged them to enlist on *Alabama*. He "gave them a brief account of the war…They would be fighting, I told them, the battles of the oppressed against the oppressor…. I spoke of good pay, and payment in gold." Butcher had brought "about sixty men" from Liverpool on *No. 290* and *Bahama* had "about thirty more. I

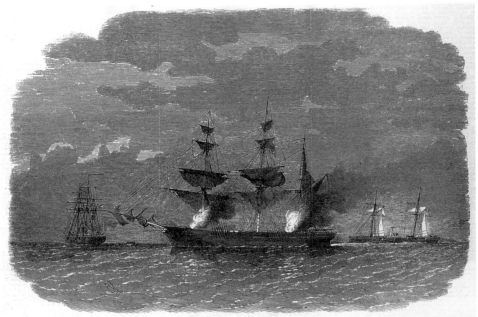

THE ALABAMA DESTROYING THE TEXAN STAR, OR MARTABAN, IN THE MALACCA STRAITS—THE KWAN-TUNG, CHINESE WAR-STEAMER, IN THE DISTANCE.
FROM A SKETCH BY COMMANDER ALLEN YOUNG, R.N.

Fig. 5. "The Alabama Destroying the Texan Star, or Martaban, in the Malacca Straits—The Kwan-Tung, Chinese War-Steamer, in the Distance. From a Sketch by Commander Allen Young, R.N.," *Illustrated London News*, April 2, 1864. The New York Public Library, Astor, Lenox and Tilden Foundations

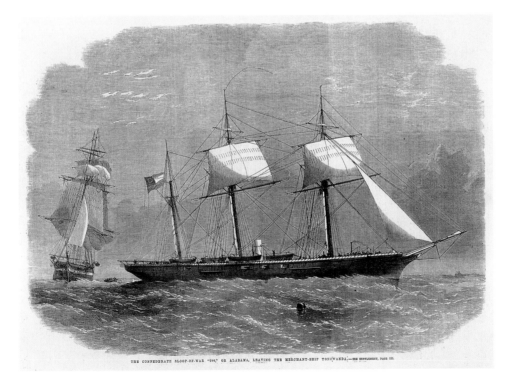

THE CONFEDERATE SLOOP-OF-WAR "290," OR ALABAMA, LEAVING THE MERCHANT-SHIP TONOWANDA.—SEE SUPPLEMENT, PAGE 533.

Fig. 6. "The Confederate Sloop-of-War '290,' or Alabama, Leaving the Merchant-Ship Tonowanda," *Illustrated London News*, November 15, 1862. Research Library, The Getty Research Institute, Los Angeles

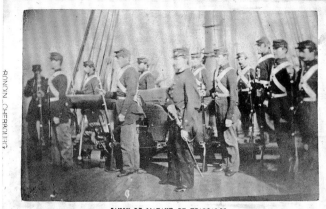

CANON DE L'AVANT DU KEARSARGE

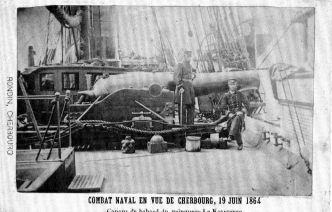

COMBAT NAVAL EN VUE DE CHERBOURG, 19 JUIN 1864
Canons de babord du vainqueur Le Kearsarge

ÉQUIPAGE DU KEARSARGE, POSTE DE COMBAT

Fig. 7. **FRANÇOIS SÉBASTIEN RONDIN.** *Canon de l'avant du Kearsarge*, 1864. Albumen silver print, image 2 5/16 x 3 11/16 in. (5.8 x 9.3 cm). Private collection, London

Fig. 8. **FRANÇOIS SÉBASTIEN RONDIN.** *Équipage du Kearsarge, poste de combat*, 1864. Albumen silver print, image 2 1/4 x 3 5/8 in. (5.7 x 9.2 cm). Manuscript Division, Library of Congress, Washington, D.C.

Fig. 9. **FRANÇOIS SÉBASTIEN RONDIN.** *Combat naval en vue de Cherbourg*, 1864. Albumen silver print, image 2 1/4 x 3 3/4 in. (5.7 x 9.5 cm). Manuscript Division, Library of Congress, Washington, D.C.

got eighty of these ninety men, and felt very much relieved in consequence."[21]

The political and legal crisis occasioned by the launching of *No. 290* made it famous, and within days of being commissioned *Alabama* the ship was back in the papers, which played a critical role in its impact on the American Civil War. Of course *Alabama* would have had no press if Semmes had not been as enterprising or as abrasive as he was. But the press attention had the effect of magnifying his successes and exalting his escapes. Semmes was what we would now call a media figure long before the battle with *Kearsarge;* indeed, he was a celebrity quite as we understand the term today. The *Times* kept track of his exploits in a stream of bulletins. The *Illustrated London*

News filled its columns of "Foreign and Colonial News" and the space at the bottom of text columns with innumerable paragraphs about *Alabama,* its captures, the anguish of American businessmen, and the impotent ire of "the Federals."[22] The *Illustrated London News,* like the *Times* and most other "leading" periodicals published in London, embraced the Confederate cause for almost the entire duration of the American Civil War and lost no opportunity to denigrate the United States. It published at least seven wood engravings celebrating the rogue vessel and its captain, including two views of *Alabama* in the heat of action (figs. 5, 6) and three portrayals of Semmes and *Alabama* officers based on photographs taken in South Africa in August or September of 1863.

As of March 4, 1861, the U.S. Navy possessed ninety vessels, twenty-one of which were being overhauled; of those remaining only twenty-four were in commission.[23] U.S. Navy Secretary Gideon Welles needed many more than that to blockade a coastline 3,500 miles long.[24] Welles therefore launched an ambitious program of acquisition and construction. U.S.S. *Kearsarge* was one of the steam sloops that he ordered to be built. It was roughly 198 feet long, 34 feet across, and displaced 1,550 tons: third-rate in the navy's classification system (figs. 7–10).[25] Construction began on June 17, 1861—one day before *Sumter* set sail—so *Kearsarge* cannot have been intended to hunt "pirates." It was thus probably a matter of routine or convention that *Kearsarge* had masts and sails. It was fortunate that it did have them, however, because before *Kearsarge* was commissioned, on January 24, 1862, Welles changed its orders from blockade duty in American coastal waters to the much more demanding task of chasing commerce raiders. In other words, *Kearsarge* had to be able to cross oceans; ships were limited in the amount of coal that they could carry, and finding coal in foreign places was always a problem. *Kearsarge* had seven guns. In addition to the run-of-the-mill 32-pounders that fired shot (conventional cannonballs)—the standard for the time—it had two 11-inch Dahlgren smoothbore cannons, a new technology. Each Dahlgren gun weighed 15,700 pounds and could fire shells—metal canisters packed with powder that exploded on contact.[26]

Welles ordered the captain of *Kearsarge,* Charles Whipple Pickering (1815–1888), to "proceed…with all possible dispatch to Cadiz, in Spain, in search of the piratical steamer *Sumter.*"[27] The crossing from the navy

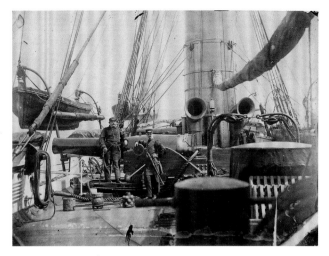

Fig. 10. **FRANÇOIS SÉBASTIEN RONDIN.** *Officers on the Deck of U.S.S. "Kearsarge,"* 1864. Albumen silver print, image 6 ⅛ x 8 ⅜ in. (15.6 x 21.2 cm). The Metropolitan Museum of Art, New York, Funds from various donors, 2003 (2003.113)

yard at Portsmouth, New Hampshire, to Madeira took seventeen days and three hours. Pickering learned on Madeira that *Sumter* had left Cadiz "and was last heard of at Gibraltar, which port [it] was ordered to leave within twenty-four hours."[28] As we have seen, *Kearsarge* arrived at Gibraltar, on March 8, 1862, where it encountered a tense diplomatic situation caused by the captain of U.S.S. *Tuscarora,* who had been keeping watch on *Sumter.*

Great Britain and the United States had weathered a serious diplomatic storm in November 1861 concerning Federal and Confederate ships in British waters. On January 31, 1862, British Foreign Secretary John Russell had issued new neutrality rules, including the so-called twenty-four-hour rule— or rules, for in fact there were two of them. The first stipulated that a "ship of war or privateer of either belligerent" that entered a British port was not to remain there for more than twenty-four hours unless weather or the need for provisions or repairs prevented its departure. The second held that if there were "vessels…of both…belligerent parties in the same port, roadstead, or waters…there shall

be an interval of not less than twenty-four hours between the departure…of the one belligerent" and the departure "of any ship of war or privateer of the other…."[29] The first rule was designed to prevent belligerent vessels from using British ports as bases of operation; the aim of the second rule was to prevent belligerent vessels from fighting in British waters. Titus Augustus Craven, captain of *Tuscarora,* was vexed that the British rulers of Gibraltar had allowed *Sumter* to remain there. The new rules had taken effect only after Semmes had anchored, however, and *Sumter* was therefore exempt.

By the time Pickering reached Gibraltar *Sumter* was no longer an effective threat to American shipping, but none of the U.S. Navy men or diplomats in or anywhere near Gibraltar knew that. As we learned earlier, Semmes eventually paid off his remaining crew and sailed for Great Britain. Although *Sumter* had destroyed only ten American merchant ships, Semmes had seriously undermined the American psyche—Americans felt threatened where once they had felt safe. The U.S. Navy could not relax its guard. Mere rumors from Liverpool in February 1862 that new Confederate cruisers were about to be launched drew U. S. warships to the mouth of the Mediterranean, where it was believed the ships would be armed.

A telegram from James E. Harvey, U.S. ambassador to Portugal, pulled Pickering away from what was seemingly an interminable watch on *Sumter:* "Information just received requires your immediate presence at Azores. Semmes, in *Alabama,* has destroyed ten whalers…. Depredations were committed near Flores. No delay admissible."[30] Between October 1 and 25, 1862, Pickering sailed around Faial and Terceira Islands in search of *Alabama,* but he did not find it. "Nothing reliable had been heard" since September 19, he reported to Welles, who, on rumors that "the notorious pirate Semmes, formerly of the *Sumter,* coaled a steamer" in Barbados, mobilized his West India Squadron.[31] Welles ordered Pickering to "remain on the European coast in the best position for watching the enemy and protecting our commerce" and to visit the Azores and Madeira "as often as advisable."[32] Welles had *Kearsarge, Tuscarora,* and *St. Louis* "cruising somewhere about the Azores" and *Mohican, San Jacinto, Onward, Sabine,* and *Ino* crisscrossing the North and South Atlantic—all things considered, an extraordinary outlay of resources for a single "pirate."[33]

News of *Alabama*'s conquests accumulated. On November 2, 1862, Welles learned that since the beginning of October Semmes had bonded two more vessels and burned six.[34] In the meantime, Pickering decided to have *Kearsarge*'s machinery repaired at Cadiz. After a lengthy stay, the ship took on coal, provisions, and powder,[35] and on March 26 Pickering sailed for the Azores, where he transferred command of *Kearsarge* to John Ancrum Winslow (1811–1873).

Early in his U.S. Navy career, Winslow had been assigned to U.S.S. *Missouri,* one of the navy's first steamships. In the Mexican War he commanded the revenue cutter *Morris,* which sank on a reef off Vera Cruz. As a result of that mishap, Winslow lodged on U.S.S. *Raritan,* where for about ten days he shared quarters with Raphael Semmes, who was temporarily on *Raritan* because he had just lost *Somers.* In a letter home Winslow recorded the banter that passed between the two men: "On board our ship is the Captain of the *Somers.* He…was temporarily in command of the *Somers* when she was wrecked…. All the officers and men saved are here in the

ship. Semmes, the Captain that was, I am very intimate with, so I frequently say, 'Captain Semmes, they are going to send you out to learn to take care of ships in blockade,' to which he replies, 'Captain Winslow, they are going to send you out to learn the bearing of reefs.'"[36]

WINSLOW AND U.S.S. *KEARSARGE* KEEP WATCH OFF THE FRENCH COAST

At the point when Winslow assumed command of *Kearsarge,* the Confederate Navy had three commerce raiders at sea: *Georgia, Florida,* and *Alabama.* Winslow had orders to "keep on the European Coast, touching at Madeira and the Azores," he told an unidentified correspondent, "and for the next two months I shall be between the two last…. As the *Alabama* was reported to be off the Western Islands [Azores] I go at once in pursuit of her."[37] Intelligence received at Madeira early in September abruptly changed Winslow's meanderings. He was told that C.S.S. *Florida* had been sighted in the Irish Channel, and he immediately set out against "a continual heavy wind from the north and eastward" that compelled him to put in at Ferrol, Spain.[38] There Winslow learned that *Florida* had in fact "put into Brest," one of France's five naval bases. He wrote to Welles that *Florida*'s captain had chosen Brest as his refuge for "the difficulty of blockade" there, and on learning from French Vice Admiral Gueydon, head of the naval district headquartered in Brest, that Gueydon had accorded *Florida* "the rights of a belligerent," Winslow realized that he was going to have to wait.[39] Two more Confederate raiders complicated Winslow's task. C.S.S. *Georgia* had put into Cherbourg on October 28, and C.S.S. *Rappahannock,* which, after just barely escaping detention by British officials at Sheerness

and burning out bearings on its way into the Channel, had been towed to Calais on November 27. There were repeated reports that one or another ship was about to sail. Winslow had no way of knowing that *Rappahannock* would be tied up in French red tape until the end of the war and that all the reports about *Florida* and *Georgia* were wrong. So he watched, waited, and fretted.

When *Florida* finally left Brest at some point between midnight and 2 A.M. on February 10, 1864, *Kearsarge* was returning from Cadiz after making a much-deferred run to replenish its stores. *Florida*'s departure was a result not of Winslow's absence but of pressure from French officials, who had been convinced by the threat of a clash between *Kearsarge* and *Florida* in French waters that they had to change their policy toward belligerents. They found their model in the British twenty-four-hour rule, as set forth by John Russell in January 1862. French Navy Secretary Prosper de Chasseloup-Laubat published the new French rules in a circular dated February 5, 1864, a copy of which Winslow sent to Washington. Winslow spent most of the next three and a half months cruising the Channel, his watch made more difficult by bad weather and by the rules now being enforced by both English and French officials.[40]

While off Dover on May 30, 1864, Winslow wrote home: "As there is nothing…to keep me in the Channel, and I can't go into either English or French ports for over twenty-four hours, I am going up to Flushing [Vlissingen] again, to remain until I hear something more decided about the *Rappahannock.*"[41] *Kearsarge* spent the last day of May and the first twelve days of June at Vlissingen, a Dutch port and seaside resort on the North Sea. A telegram from Édouard Liais, U.S. Vice Consul in Cherbourg, to U.S.

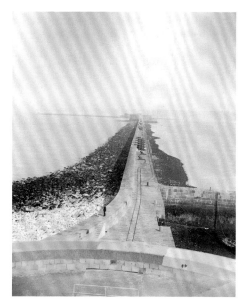

Fig. 12. **UNKNOWN ARTIST.** *Passe Ouest de la rade. Digue. Fort Chavaignac [sic].* Albumen silver print, 13 ³⁄₈ x 10 ⁵⁄₈ in. (34 x 27 cm). Service Historique de la Marine, Cherbourg

Fig. 11. **UNKNOWN ARTIST.** *Digue (branche Est). Vue prise du fort central.* Albumen silver print, 13 x 10 in. (33 x 25.5 cm). Service Historique de la Marine, Cherbourg

Ambassador William L. Dayton Sr. in Paris on Saturday, June 11, roused everyone from their routine employments: A Confederate cruiser had arrived at Cherbourg. Several hours later, Liais telegraphed again: The cruiser was *Alabama*, and it had "thirty-seven Federal prisoners." Dayton telegraphed Winslow, who replied that he would "be off Cherbourg about Wednesday."[42] Expecting *Alabama*'s stay at Cherbourg to last as long as *Florida*'s at Brest, Dayton also lodged a protest with French Foreign Minister Édouard Drouyn de Lhuys.[43]

Winslow stopped at Dover in order to get a new sail, pick up letters, and send telegrams (he did not trust the telegraph system in France).[44] Meanwhile, Liais was looking after Semmes's former prisoners and writing to Winslow about his interviews with them. Being seamen, they were able to provide useful intelligence about *Alabama*: "Her speed under steam alone was about 10 knots; she needs new copper. We do not think she ever had a speed of 15 knots, as the report was."[45] At some point between 10:30 A.M. and noon on Tuesday, June 14, *Kearsarge* "steer[ed] in for Cherbourg Breakwater. Stopped the Engine off the Entrance (Eastern) and sent a boat in to Communicate with the American Consul."[46]

ALABAMA AND KEARSARGE IN THE DAYS BEFORE THE BATTLE

On Saturday, June 11, 1864, Semmes anchored *Alabama* in Cherbourg roads—the huge sheet of calm water sheltered from Channel currents by a breakwater 2.3 miles long (figs. 11, 12).[47] He sent someone ashore to ask local authorities for permission to land thirty-seven men, two women, and one child who had become his prisoners after he captured and burned *Rockingham* and *Tycoon*, U.S. merchant vessels, on his way from South Africa to the English Channel. Vice Admiral Adolphe-

Augustin Dupouy, head of the naval district headquartered in Cherbourg, telegraphed French Navy Secretary Chasseloup-Laubat, his immediate superior, for instructions.[48] He had been told that Semmes was going to ask his permission to have *Alabama* repaired in the naval base. Dupouy was worried: Should he allow Semmes to dock without further ado, or should he "appoint a commission to assess *Alabama*'s needs?"[49]

About 4 P.M. John McIntosh Kell, *Alabama*'s second in command, went ashore with a letter from Semmes. According to Semmes, in order to be seaworthy *Alabama*'s hull needed to be recoppered, and its boilers required extensive repairs. Semmes called on Dupouy to let him dock at the naval base and take advantage of its facilities.[50] Chasseloup-Laubat told Dupouy that he should allow Semmes to land the prisoners, who would be free as soon as they set foot on French soil. But the navy secretary then asked in code: "What kind of repairs does the ship need?"[51] On Sunday morning Chasseloup-Laubat again wired Dupouy in code: "Is it *Alabama,* or is it *Florida*? Who is captain?"[52] Dupouy confirmed that the ship was *Alabama* and that the captain was Semmes.[53]

On Tuesday, June 13, a U.S. Navy steamer—*Kearsarge*—was sighted in the Channel. At first the ship seemed headed for the roads, but instead it stopped short and sent a boat carrying an officer to meet with Captain Jérôme-Hyacinthe Penhoat, who commanded *Couronne*, the French navy flagship in Cherbourg. Penhoat reported to Dupouy that the officer had asked permission to communicate with the U.S. vice consul in Cherbourg and to anchor *Kearsarge* in the roads.[54] Penhoat told the officer that he would alert port medical authorities and that the officer could communicate with the U.S. vice con-

sul as soon as they authorized him to do so. In response to the officer's request to anchor, Penhoat handed him a partial copy of Chasseloup-Laubat's February 5 circular. The officer realized what that meant—the twenty-four-hour rule would come into play if *Kearsarge* entered the roads[55]—so he declined to wait and returned to *Kearsarge*.[56] A little more than an hour later Winslow sent another boat ashore, commanded by ship's surgeon John M. Browne, that succeeded in contacting U.S. Vice Consul Liais.[57] Liais then contacted A. Bonfils, the Confederate agent in Cherbourg, who relayed a message to Semmes that *Kearsarge* had come to Cherbourg "solely for the prisoners landed by [Semmes] and that [*Kearsarge*] was to depart in twenty-four hours."[58]

"Twenty-four hours" was the key phrase. Dupouy sent Penhoat a note instructing him to send a boat to *Kearsarge* and ask its captain whether he intended to come to anchor.[59] Semmes sent Dupouy a written protest about the prisoners—*Kearsarge* should not be allowed to increase its fighting force.[60] He also ordered his men to prepare *Alabama* to sail, that is, he ordered the engineers to start the fires under the boilers.[61] He realized that if *Kearsarge* did not enter the roads it was not bound by the twenty-four-hour rule; it would therefore be free to challenge him, or chase him, whenever he emerged. When Dupouy learned of Semmes's order he dispatched his *premier aide de camp* to *Alabama*. Semmes told that emissary that he had made up his mind to leave the roads and attack "the Federal." *Kearsarge* had not entered the roads, Semmes argued, so his only obligation was not to attack *Kearsarge* in French territorial waters. Dupouy disagreed and sent the aide back to ask Semmes not to leave. To calm Semmes, Dupouy made a show of refusing Winslow's request to board *Alabama*'s prison-

Fig. 13. **CHAM (AMÉDÉE DE NOÉ).** Caricature from "Revue Trimestrielle," published in *L'Illustration*, October 29, 1864. "The Confederate Captain Semmes has the courtesy to await the pleasure train from Paris before beginning military action."

Le capitaine confédéré Semmes ayant la gracieuseté d'attendre l'arrivée du train de plaisir parti de Paris pour commencer le branle-bas de combat.

ers. But, he let Semmes know, if Semmes tried to leave, Dupouy would stop him by force. Dupouy did not want "Federal" and "rebel" to fight on his watch.

Captain Winslow called on Dupouy on Wednesday, June 15, and "admitted" that he had come not for *Alabama*'s prisoners but for Semmes and that he intended to cruise in the Channel until Semmes left the roads. Dupouy gave Winslow a choice: either come into the roads and anchor—permission had been granted on Tuesday—or "go away." Winslow "recognized the merit of Dupouy's position" and said that he would wait for *Alabama* in the Channel.[62] Later that day Dupouy received a telegram from Chasseloup-Laubat saying that *Alabama* could not dock or be repaired in the naval base, but before Dupouy could convey that decision to Semmes, Semmes withdrew his earlier request and instead asked

permission to buy coal for his ship from private suppliers. Semmes, it seems, had resolved to fight Winslow.

Chasseloup-Laubat wrote a long, indignant note to the French foreign minister, who then talked with Ambassador Dayton. Mindful of the concerns relayed to him, Dayton drafted a note for Winslow and had his son take it to Cherbourg. "I do not suppose that they would have, on principles of international law, the least right to interfere with you 3 miles off the coast," he wrote Winslow, "but if you lose nothing by fighting 6 or 7 miles off the coast instead of 3 you had best do so.... I do not wish you to sacrifice any advantage if you have it. I suggest only that you avoid all unnecessary trouble with France...."[63] Sending his son to Cherbourg with the note had less to do with keeping its contents secret than with the technological limits of messaging in 1864. *Kearsarge* was out at sea. As the junior Dayton reported to his father late Friday night: "Consul says that authorities have made no communication to Capt Winslow. Capt W will not come into Cherbourg."[64]

On Thursday, June 16, Dupouy wired Chasseloup-Laubat that *Kearsarge* was still sailing back and forth within sight of the port but never less than three nautical miles from the breakwater, waiting for *Alabama* to leave. *Alabama* had loaded its coal, Dupouy reported, and Semmes intended to leave during daylight to attack *Kearsarge*. He told the navy secretary that he would "prevent them from fighting any less than four or five nautical miles from shore...."[65] Dupouy sent another, confidential wire to Paris that afternoon: I have no idea when *Alabama* is going to leave. If he wants to leave, I won't stop him. If he doesn't, I won't force him to. But if *Alabama* leaves, I will have *Couronne* make sure that the two ships do not fight in territorial

waters.[66] Chasseloup-Laubat replied late Friday morning: *Kearsarge* is always outside territorial waters, so there is nothing else that you can do. If *Alabama* wants to leave, you can't stop it.[67]

Having taken on his coal, Semmes informed Samuel Barron, whom he described as his "senior officer in Paris," that he intended to fight Winslow, but apparently he did not tell him when. According to Semmes's memoirs, he had Francis Galt, his "acting paymaster…send on shore for safe-keeping, the funds of the ship, and complete pay-rolls of the crew."[68] Finally, on Saturday, Semmes gave Dupouy the news that he had been waiting for: *Alabama* was going to leave Sunday morning, June 19, 1864, between 9 and 10 A.M. Until early Saturday afternoon, however, no one, not even Semmes, knew when *Alabama* was going to leave. Subsequent claims that the battle was somehow deliberately staged—an interpretation of events supported by satirical cartoons at the time (fig. 13)—have no basis in fact.

SUNDAY, JUNE 19, 1864

Many writers have told the story of the encounter between U.S.S. *Kearsarge* and C.S.S. *Alabama*.[69] Most of the resulting narratives are partisan, some writers speaking for the Federals, others for the Confederates. These narratives also have an internal consistency because they draw on a selected body of documents: Winslow's reports to Gideon Welles, or the accounts published by Semmes in English newspapers and in his recollections. If one looks beyond these selective bases of information to other, independent nineteenth-century printed and manuscript sources, the consensus dissolves into a blur of conflicting details. There are, nonetheless, a certain number of points that cannot be disputed. On the morn-

ing of Sunday, June 19, *Alabama* left the Cherbourg roads followed by the French navy flagship, *Couronne*, and accompanied by a steam yacht flying the Union Jack and a British yacht club flag *(Deerhound)*. *Couronne* returned to the roads, but *Deerhound* did not. *Alabama* fired the first shot. Having elected to fight starboard to starboard, *Alabama* and *Kearsarge* then steamed in interlocking circles five to seven times as the current pushed them west. *Alabama* sank, and *Kearsarge* returned to anchor on the land side of Cherbourg's breakwater.

Everything that we know about the engagement—above all about the individual incidents on board the two vessels during the fighting and in the immediate aftermath—comes from personal accounts. The most detailed and colorful of these accounts were written weeks, months, sometimes even years later. Although the battle received ample coverage in French and English newspapers, that coverage was both biased and information-poor in the sense that newspaper after newspaper printed the same wire service reports, the same statements and letters over and over again. As a result, much of the coverage was, to use the modern term, spin.

There are two documents, however, apparently written within hours of one another, that have a "man-in-the-street" immediacy that helps us to sense the impact of the day's events on contemporary observers. Both writers tell us only what they saw from the very particular place where they happened to be, and both had a substantial emotional and practical stake in the outcome. In a letter to his immediate superior, Samuel Barron, George Terry Sinclair, a native of Virginia sent to Europe in 1862 to buy ships for the Confederate Navy, reported that Semmes fired the first shot, at 11:22 A.M. "After some ex-

Bains de mer de Cherbourg.

The relative position of the vessels at this time and afterwards was as follows

Cherbourg
Alabama

the dark line represents the Route of Kearsage & the other that of the Alabama

The Kearsage at first instead of running directly towards the Alabama headed out to sea and ran a few miles on a line parallel with the

Fig. 14. Letter from William L. Dayton Jr. to William L. Dayton Sr., June 19, 1864, p. 1. William L. Dayton Papers, Manuscripts Division, Department of Rare Books and Special Collections, Princeton University Library

Fig. 15. Letter from William L. Dayton Jr. to William L. Dayton Sr., June 22, 1864, p. 7. William L. Dayton Papers, Manuscripts Division, Department of Rare Books and Special Collections, Princeton University Library

changes at long range, they passed each other, using their starboard batteries. They then passed & repassed, always using the same battery (which Semmes had told me was his intention) after passing the ~~seventh~~ eighth time, I observed Semmes make sail forward, and stand in, and I thought I saw smoke issuing from the ship." He noted that the "Prefect" (Dupouy) told him that *Alabama* "went down with her <u>colors flying</u>…the Flag…was the last

thing to disappear." Sinclair's own view of the climactic moment had been obscured by a house.[70]

The second letter was written by William L. Dayton Jr. As already noted, U.S. Ambassador William L. Dayton Sr. had sent his son to Cherbourg with messages for Captain Winslow, which he delivered to *Kearsarge* on Saturday. Unaware of Semmes's intentions, Winslow asked Dayton to order

coal through the U.S. consul in Le Havre, but when Dayton came ashore Dupouy told him that *Alabama* would leave the next morning. On Sunday morning U.S. Vice Consul Liais guided Dayton to "an elevated spot of ground" in Querqueville—most likely the hill on which a chapel dedicated to Saint Germain has stood since the tenth century—from which he could observe the battle.[71] Returning to town after *Alabama* had sunk, but before *Kearsarge* had entered the roads, Dayton first telegraphed the news to his father and then scribbled a note to him in pencil on the stationery of the Cherbourg Bains de Mer (fig. 14):

> *Sunday quarter*[72]
> *before 2 o'clock —*
>
> *Dear Pa —*
> *I am happy to inform you very hastily that I this morning saw a fight between the Kearsage*[73] *& Alabama which lasted one hour and a half, at the end of which time the Alabama tried to run away but could not escape the K which pursued Apparently she then surrendered for the firing stopped —*
> *A few moments after two boats were seen putting out from the Kearsage but before they could reach her, she went down in a second apparently with every thing* ~~& body~~ *on board —*
> *I saw the whole* ~~thing~~ *affair from an elevated position near Cherbourg —*
> *The K will I suppose at once come into the port, where I will go to congratulate them — The Consul wishes me to congratulate you on the success and say*

> *he feels happy to have done his best on shore to assist the Kearsage —*
> *I shall not probably return before to morrow or next day — I was up this morning at 8 and have eaten nothing all day — With much love,*
>
> > *William L Dayton Jr*
> *I have just sent you a telegram — It is impossible to say whether the Alabama sank by her proper act or not — I think not.*
> > *The Alabama went out boldly in open day to meet the Kearsage —*

Three days later, Dayton, who had returned to Paris after conducting Semmes's former prisoners to Le Havre, addressed a twenty-nine-page letter to his father.[74] The letter appears to have been written at his father's request, not to convey fresh news but for the record.[75] The junior Dayton drew deeply on conversations he had with Captain Winslow and *Kearsarge* officers on and after Sunday. Much of his information about the naval engagement can be found in the reports that *Kearsarge* officers addressed to Winslow and that Winslow addressed to Gideon Welles. The one new note in Dayton's letter is a sketch he made, reproduced here for the first time (fig. 15). It gives us our first glimpse of the elaborate maplike diagram that Winslow sent to Washington from Dover on July 30 with his supplementary report to Gideon Welles (fig. 16).[76] Winslow's diagram shows "the general direction and position of the Action" on June 19. Given his personality, Welles may have been a bit annoyed when he finally received the document, because an enterprising *New York Herald* reporter in Cherbourg had

Fig. 16. Hand-drawn map of the courses sailed by U.S.S. *Kearsarge* and C.S.S. *Alabama* on June 19, 1864, by John Ancrum Winslow. Brown and blue ink on tracing paper, 17 3/4 x 12 in. (45.1 x 30.5 cm). National Archives, Washington, D.C.

Fig. 17. Front page of the *New York Herald*, July 9, 1864. "The Naval Battle off Cherbourg: Scene of the Engagement Between the Rebel Steamer Alabama and the United States Steamer Kearsarge." The New York Public Library, Astor, Lenox and Tilden Foundations

managed to make some sort of replica of the diagram, which he sent to New York and which the *Herald* published on the front page of its July 9 issue (fig. 17).[77] Winslow's reports to Welles and his diagram had a considerable impact on American opinion in their own time, and they were widely drawn on by twentieth-century historians,[78] but neither they, nor

Dayton's letter, nor the unnamed *New York Herald* reporter had any impact on French media in 1864.

Public discussion of the event in France was dominated by accounts first published in English papers, above all by the pro-Semmes, pro-Confederate "official reports" and letters published in the *Times*. One detail in Dayton's

COMBAT NAVAL.
(L'Alabama coulant sous le feu de Kearsage.)

Fig. 18. **CHARLES LONGUEVILLE**. *Combat naval (L'Alabama coulant sous le feu de Kearsage [sic]*. Etching, image 8 ⁵⁄₈ x 11 ⁷⁄₈ in. (22 x 30.3 cm). The Metropolitan Museum of Art, New York, Gift of William H. Huntington, 1883 (83.2.954)

letter illustrates the importance of that coverage: Dayton identifies the "English yacht" as *Deerhound*. But neither Dayton nor Winslow could have known *Deerhound*'s name unless he had read the issue of the *Times* dated June 20, 1864. This detail is important for Manet's knowledge of the event. No matter what the politics of an individual paper happened to be, virtually every Paris daily and many provincial papers—even the two papers in Cherbourg—published the same Agence Havas wire service report about the battle, which drew exclusively on the version of events presented to the world by the *Times*. Semmes lost the battle, but he won the ensu-

ing propaganda war, thanks in large part to the *Times* and the authority that it wielded in the media universe of the day.

The *Times* was instrumental in publicizing Semmes's three main complaints against Winslow's conduct, the first being that Winslow had somehow deceived Semmes or cheated on the rules of war by "armoring" his vessel, and that this was somehow unfair. (While at Faial, Spain, in late April 1863, *Kearsarge* had been "plated" with "heavy chains, suspended close together, which are hung to the sides of the vessel, and makes a complete armor for protection against shot, etc."[79] Here it should be noted that Semmes

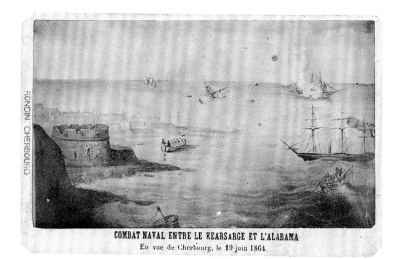

Fig. 19. **FRANÇOIS SÉBASTIEN RONDIN.** *Combat naval entre le Kearsarge et l'Alabama* (photograph of an unknown painting), 1864. Albumen silver print, image 2 ¼ x 3 ⅞ in. (5.8 x 9.9 cm). Private collection, London

Fig. 20. **AFTER WARREN SHEPPARD.** *Sinking of the Alabama,* 1897. Commercial lithograph, image 4 ½ x 7 in. (11.4 x 17.8 cm). The Metropolitan Museum of Art, New York, Gift of Joseph Verner Reed, 1964 (64.542.205)

was in the habit of displaying the flag of Great Britain or the United States to get within range of a merchant vessel that he wanted to capture. Under the prevailing rules of war, he had to display the Confederate flag before he could fire on his prey, but replacing the ruse flag with the Confederate flag took no more than an instant.) Semmes's second complaint was that *Kearsarge* fired on *Alabama* after it surrendered. Because its Confederate flag had been shot from the mainmast during the fight, Semmes had to improvise a white flag to notify his surrender. Semmes did not surrender until *Alabama* had started to sink, however, and in some versions of his story, Semmes denied that *Alabama* had indeed surrendered. As George Terry Sinclair's eyewitness account

recalled, "[*Alabama's*] Flag . . . was the last thing to disappear." Third, Semmes complained that Winslow had been slow to start his rescue efforts. Semmes was unaware that his gunners had punched *Kearsarge's* starboard boats full of holes; *Deerhound* and the three French pilot boats that between them picked up fifty-odd men were thus providential. Paris papers repeated, varied, and amplified all these charges. The conflicting details would have challenged anyone who undertook to construct an exact or authentic representation of the great naval duel (figs. 18–20). But, as observed earlier, the canons of naval painting did not require authenticity. The audience for such work demanded only that a work be plausible— and interesting.

NOTES

1. *The Collected Works of Abraham Lincoln,* ed. Roy P. Basler, Marion Dolores Pratt, and Lloyd A. Dunlap, vol. 4 (New Brunswick, N.J.: Rutgers University Press, 1953), pp. 331–33.

2. Ibid., pp. 338–39. A second proclamation, dated April 27, extended the blockade to the ports of Virginia and North Carolina; ibid., pp. 346–47.

3. Richard Henry Dana, in Henry Wheaton, *Elements of International Law: The Literal Reproduction of the Edition of 1866 by Richard Henry Dana, Jr.,* ed. George Grafton Wilson (Oxford: Clarendon Press, 1936), p. 31.

4. Gideon Welles, *Lincoln and Seward: Remarks upon the Memorial Address of Chas. Francis Adams, on the Late Wm. H. Seward* (New York: Sheldon & Company, 1874), pp. 122–23.

5. John Niven, *Gideon Welles: Lincoln's Secretary of the Navy* (New York: Oxford University Press, 1973), p. 357.

6. *Montgomery (Ala.) Daily Confederation,* May 19, 1858, quoted by Robert Royal Russel, *Economic Aspects of Southern Sectionalism, 1840–1861* (Urbana: University of Illinois, 1924), p. 207.

7. J. Thomas Scharf, *History of the Confederate States Navy from Its Organization to the Surrender of Its Last Vessel,* 2nd ed. (Albany, N.Y.: Joseph McDonough, 1894), p. 27.

8. Raphael Semmes, *Service Afloat and Ashore during the Mexican War* (Cincinnati: Wm. H. Moore & Co., 1851), p. 93. Thirty-nine members of Semmes's crew perished. For the identification of the vessel that Semmes pursued as *John Adams,* see Matthew C. Perry's letter to U.S. Navy Secretary John Y. Mason in the same volume, p. 94.

9. Dates for Semmes are from his ZB (biographical) file, U.S. Navy Department Library, Washington, D.C.

10. Raphael Semmes, *Memoirs of Service Afloat, during the War between the States* (Baltimore: Kelly, Piet & Co., 1869), p. 75.

11. Ibid. For Conrad, see Scharf, *Confederate States Navy,* p. 27.

12. See Davis's letter to Semmes of February 21, 1861, *The War of the Rebellion: A Compilation of the Official Records of the Union and Confederate Armies,* ed. Fred C. Ainsworth and Joseph W. Kirkley, ser. 4, vol. 1 (Washington, D.C.: Government Printing Office, 1900), pp. 106–7.

13. Semmes, *Memoirs,* p. 88.

14. Ibid., p. 93.

15. Ibid., p. 94.

16. Ibid., p. 348

17. Stephen R. Mallory to Bulloch, May 9, 1861, *Official Records of the Union and Confederate Navies in the War of the Rebellion* (Washington, D.C.: Government Printing Office, 1894–1922), ser. 2, vol. 2, pp. 64–65.

18. See "The Civil War in America. By the Queen.—A Proclamation," *Times* (London), May 15, 1861, p. 5. The *Times* cites "Tuesday's *Gazette*" as its source.

19. See Warren F. Spencer, *The Confederate Navy in Europe* (University, Ala.: University of Alabama Press, 1983), p. 102.

20. The circumstances of *No. 290*'s sailing are somewhat obscure. See Douglas H. Maynard, "Plotting the Escape of the *Alabama,*" *Journal of Southern History* 20 (May 1954), pp. 197–209, and his "Union Efforts to Prevent the Escape of the *Alabama,*" *Mississippi Valley Historical Review* 41 (June 1954), pp. 41–60.

21. Semmes, *Memoirs,* pp. 410–12.

22. The earliest "Foreign and Colonial News" item that we have noted is in the issue of November 1, 1862, p. 454. The earliest filler item that we have seen is in the issue dated January 10, 1863, p. 42.

23. Gideon Welles, "Report of the Secretary of the Navy to the President of the United States," in *Message of the President of the United States to the Two Houses of Congress, at the Commencement of the First Session of the Thirty-Seventh Congress,* July 5, 1861 (Washington, D.C.: Government Printing Office, 1861), pp. 85–86. The "List and Stations of United States Vessels of War in Commission, March 4, 1861" (*Official Records...Navies,* ser. 1, vol. 1, pp. XV–XVI) tallies thirty-nine ships—one being recorded as "lost." We cannot explain the differences.

24. "The extent of this blockade, according to an accurate table of measurement carefully prepared at the Coast Survey office, covers a distance of three thousand five hundred and forty-nine statute miles, with one hundred and eighty-nine harbor or river openings or indentations, and much of the coast presents a double shore to be guarded." Gideon Welles, "Report of the Secretary of the Navy to the President, December 7, 1863," in *Message of the President of the United States, and Accompanying Documents, to the Two Houses of Congress, at the Commencement of the First Session of the Thirty-Eighth Congress* (Washington, D.C.: Government Printing Office, 1863), p. iii.

25. *A Naval Encyclopaedia: Comprising a Dictionary of Nautical Words and Phrases; Biographical Notices, and Records of Naval Officers; Special Articles of Naval Art and Science* (Philadelphia: L. R. Hamersly & Co., 1881), p. 132.

26. See Donald L. Canney, *The Old Steam Navy,* vol. 1, *Frigates, Sloops, and Gunboats, 1815–1885* (Annapolis: Naval Institute Press, 1990), p. 74. Donald L. Canney, *Lincoln's Navy: The Ships, Men, and Organization, 1861–65* (Annapolis: Naval Institute Press, 1998), p. 170.

27. Welles to Pickering, January 18, 1862, *Official Records...Navies,* ser. 1, vol. 1, p. 284.

28. Pickering to Welles, February 22, 1862, ibid., pp. 320–21.

29. Text from the version in Welles to Pickering, January 18, 1862, ibid., pp. 325–27.

30. Harvey to Pickering, Lisbon, September 28, 1862, ibid., p. 490.

31. Pickering to Welles, October 6, 1862, ibid.; Welles to Charles Wilkes, October 8, 1862, ibid., p. 491.

32. Welles to Pickering, November 1, 1862, ibid., pp. 524–25.

33. Welles to Wilkes, November 1, 1862, ibid., pp. 525–26.

34. J. T. Smith to Welles, Boston, November 2, 1862, ibid., pp. 526–27. As already noted, the *Illustrated London News* illustrated *Tonowanda*, Semmes's capture of October 9 (fig. 6).

35. Pickering to Welles, March 19, 1863, *Official Records...Navies*, ser. 1, vol. 2, p. 129.

36. John M. Ellicott, *The Life of John Ancrum Winslow, Rear-Admiral, United States Navy, Who Commanded the U.S. Steamer "Kearsarge" in Her Action with the Confederate Cruiser "Alabama,"* 2nd ed. (New York: G. P. Putnam's Sons, 1905), p. 46. Semmes says nothing of Winslow in *Mexican War*. But in *Memoirs of Service Afloat* (p. 760) he remembers his early acquaintance with Winslow and turns it against him: "I had known, and sailed with him, in the old service [Confederate States jargon for *U.S. Navy*], and knew him *then* to be a humane and Christian gentleman. What the war may have made of him, it is impossible to say. It has turned a great deal of the milk of human kindness to gall and wormwood." Much having been made in 1864 of the alleged intimacy between Winslow and Semmes, we are deeply grateful to Rebecca Livingston, National Archives, Washington, D.C., for extracting the dates from the logs of U.S.S. *Cumberland* and U.S.S. *Raritan*.

37. Winslow to unidentified recipient, April 6, 1863, Ellicott, *John Ancrum Winslow*, pp. 102–3.

38. Winslow to Welles, September 15, 1863, ibid., p. 115.

39. Winslow to Welles, September 18, 1863, ibid., pp. 119–20.

40. "You can have no idea what a season we have had in the channel since November; it has been the severest for blows and cold ever known here, and in consequence of the twenty-four hour law, we are forced to keep running about for shelter from the storms, by getting under a lee. When it blows from the French side, we have to go over there, and when it blows from the English side, back we go for the same reason." Winslow to unidentified recipient, off Dover, March 18, 1864, Ellicott, *John Ancrum Winslow*, pp. 154–55.

41. Winslow to unidentified recipient, May 30, 1864, ibid., p. 173.

42. Dayton to Seward, June 13, 1864, *Official Records...Navies*, ser. 1, vol. 3, pp. 51–52. Dayton quotes Liais's wire, p. 52.

43. Dayton to Drouyn de Lhuys, June 11, 1864, ibid., p. 52.

44. "We want sails, our old ones are worn out, and I wrote home in June for a new set which were left in Portsmouth, and I am in hopes the Storeship at Cadiz has brought them." Winslow to unidentified recipient, December 20, 1863, Ellicott, *John Ancrum Winslow*, pp. 148–49. The stopover in Dover and a letter that Winslow wrote after his encounter with Semmes (Winslow to Welles, July 5, 1864, *Official Records... Navies*, ser. 1, vol. 3, p. 94) suggest that the sails were never sent.

45. Liais to Winslow, June 13, 1864, *Official Records... Navies*, ser. 1, vol. 3, p. 53. The reports of those who actually set foot on *Alabama* are less glowing than those of the newspaper writers.

46. U.S.S. *Kearsarge* log, June 14, 1864, National Archives, Washington, D.C. The log is imprecise about the exact time of *Kearsarge*'s arrival.

47. Adolphe-Augustin Dupouy to Prosper de Chasseloup-Laubat, June 12, 1864, BB4 1346 (6). The account that follows relates the documents published in *Official Records...Navies* to the 159 manuscript documents we examined at the French National Archives (Archives Nationales, Paris), the French Navy Archives, Vincennes, and the Navy History Center, Cherbourg. We give summary identifying information for the French material: BB2 429 (French navy secretary's correspondence with *préfets maritimes*) is at the National Archives; BB4 1346 and GG2 51 (a fair copy of *Kearsarge/Alabama* documents made for Vice Admiral Dupouy) are at the Navy Archives; 2A2 48 and 2A4 44 are functional files of correspondence at the Navy History Center.

48. Dupouy to Chasseloup-Laubat, June 11, 1864, 2:05 P.M., BB4 1346 (1).

49. Dupouy to Chasseloup-Laubat, June 11, 1864, 3:40 P.M., BB4 1346 (2).

50. Dupouy to Chasseloup-Laubat, June 11, 1864, 7:10 P.M., BB4 1346 (3).

51. Chasseloup-Laubat to Dupouy, June 11, 1864, 7:10 P.M., BB2 429 (62). For delivery of Semmes's letter, see Dupouy to Chasseloup-Laubat, June 12, 1864, 2A2 48 (260).

52. Chasseloup-Laubat to Dupouy, June 12, 1864, 10:37 A.M., BB4 1346 (4). This fair copy is dated 10:37 A.M. June 12. The work document, BB2 429 (64), has the time 10:15 A.M.

53. Dupouy to Chasseloup-Laubat, June 12, 1864, 4:45 P.M., BB4 1346 (5), and June 13, 1864, 8:51 A.M., BB4 1346 (7). We did not see the coded versions of these messages, which may not have been preserved.

54. Penhoat to Dupouy, June 14, 1864, GG2 51 (7).

55. For the text, see *Bulletin officiel de la marine*, 17th year, vol. 1, fasc. 1, nos. 1–492 (Paris: Imprimerie Impériale, 1864), pp. 122–23, or *Bulletin officiel de la marine: Édition refondue et annotée des "Annales mar-

itimes et coloniales" et du "Bulletin officiel de la marine," vol. 9, *1860 à 1865* (Paris: Imprimerie Nationale, 1900), pp. 492–93.

56. Penhoat to Dupouy, June 14, 1864, GG2 51 (7).

57. Unpublished manuscript journal of *Kearsarge* coal heaver William Wainwright, June 14, 1864, Log 429, G.W. Blunt White Library, Mystic Seaport, Mystic Connecticut.

58. Semmes to [Bonfils], June 14, 1864, *Official Records...Navies,* ser. 1, vol. 3, p. 648.

59. Dupouy to Penhoat, June 14, 1864, GG2 51 (8).

60. Semmes to Dupouy, June 14, 1864, GG2 51 (9).

61. Dupouy to Chasseloup-Laubat, June 15, 1864, BB4 1346 (11). This is a long letter recounting events of the preceding day. We have seen no other mention of this incident in the extensive literature on the "duel" between *Kearsarge* and *Alabama.*

62. Ibid.

63. Dayton to Winslow, June 16, 1864, *Official Records...Navies,* ser. 1, vol. 3, pp. 57–58 (quotation on p. 58).

64. Dayton Jr. to Dayton Sr., "Friday night" [June 17, 1864], unpublished manuscript letter, William Louis Dayton Papers, AM 15236, box 6, folder 2, no. 1, Firestone Library, Princeton University.

65. Dupouy to Chasseloup-Laubat, June 16, 1864, BB4 1346 (16).

66. Paraphrase of Dupouy to Chasseloup-Laubat, June 16, 1864, BB4 1346 (17).

67. Paraphrase of Chasseloup-Laubat to Dupouy, June 17, 1864, 11:30 a.m., BB2 429 (66).

68. Semmes, *Memoirs,* pp. 754–55.

69. It seems impossible to narrate the events of June 19 without taking sides. The most balanced account of the day's events that we have seen is Norman C. Delaney's in *John McIntosh Kell of the Raider "Alabama"* (University, Ala.: University of Alabama Press, 1973), pp. 161–77.

70. George Terry Sinclair to Samuel Barron, June 19 (misdated June 20), 1864, William Whittle Papers, Norfolk Public Library, Virginia. For published transcriptions of Sinclair's letter, see Frank J. Merli, "Letters on the *Alabama,* June 1864," *Mariner's Mirror* 58 (1972), pp. 216–18, and Robert Mason, "'She Died a Noble Death,'" *Naval History* 11, no. 1 (January–February 1997), pp. 30–32.

71. Dayton Papers, AM 15236, box 6, folder 2, no. 3. Querqueville, a hamlet roughly three and a half miles north and west of Cherbourg, is wedged between a hill and an alluvial plain, most of which is occupied by French navy installations. Alfred Cornelius Howland's painting *USS "Kearsarge" and CSS "Alabama," Cherbourg, June 19, 1864* (U.S. Naval Academy Museum, Annapolis) shows Saint Germain and a small crowd of people observing "two very small ships surrounded by the smoke of battle" (unpublished document, curatorial files, U.S. Naval Academy Museum).

72. Ibid.

73. The junior Dayton consistently misspells *Kearsarge*'s name.

74. Dayton Papers, AM 15236, box 6, folder 2, no. 4. William M. Leary Jr. published part of the June 22, 1864, letter as "*Alabama* Versus *Kearsarge:* A Diplomatic View," in *American Neptune* 29 (July 1969), pp. 167–73.

75. The letter was at one point kept in an envelope endorsed "Account of visit to Cherbourg on occasion of the fight between the 'Kearsarge' and 'Alabama.' W. L. D. jr. 1864."

76. John Ancrum Winslow, untitled manuscript diagram attached to his letter of Saturday, July 30, 1864, to Gideon Welles, "Letters Received by the Secretary of the Navy from Admirals, Commodores and Captains," National Archives, Washington, D.C. See *Official Records...Navies,* ser. 1, vol. 3, pp. 79–81, for the text of the letter. A version of the diagram is reproduced facing p. 81.

77. In Winslow's map some of the French designations, such as "Passe de l'Ouest" and "Passe de l'Est," have been replaced with their English equivalents that in the *Herald* map were added in brackets. (The *New York Herald* marked the area beyond the Cherbourg "Breakwater" and near the diagrammatic revolutions of the ships with the words "English Channel," perhaps as a clear and unequivocal indication that the battle took place outside French waters.)

78. Winslow's diagram was lithographed by Bowen & Co., Philadelphia, and the lithograph was tipped into Gideon Welles, "Report of the Secretary of the Navy, Navy Department, December 5, 1864," in *Message of the President of the United States, and Accompanying Documents, to the Two Houses of Congress, at the Commencement of the Second Session of the Thirty-Eighth Congress* (Washington, D.C.: Government Printing Office, 1864) between pp. 630 and 631.

79. Winslow to unidentified recipient, May 14, 1863, Ellicott, *John Ancrum Winslow,* pp. 108–9.

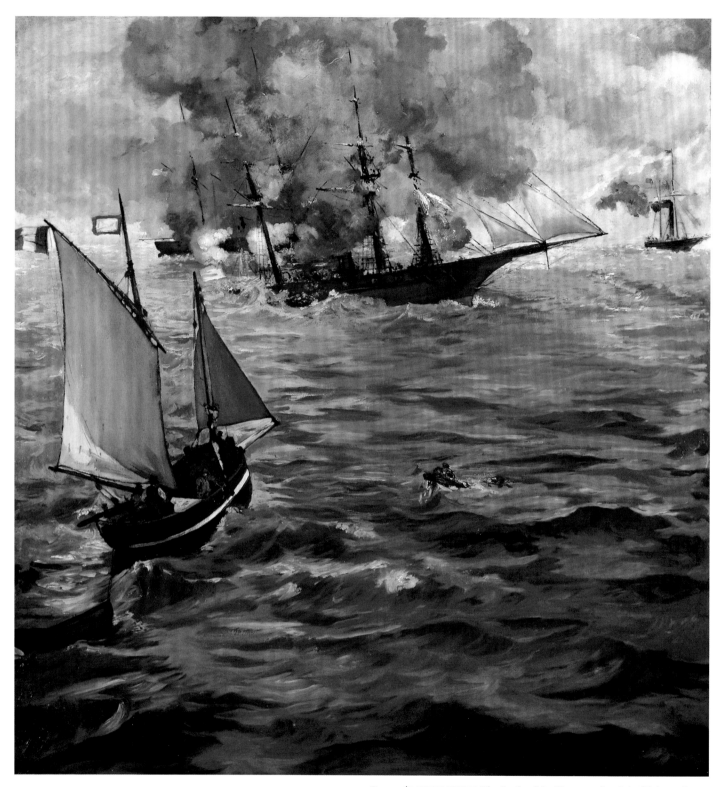

Fig. 21. **ÉDOUARD MANET.** *The Battle of the "Kearsarge" and the "Alabama,"* 1864. Oil on canvas, 52 ³/₄ x 50 in. (134 x 127 cm). Philadelphia Museum of Art, The John G. Johnson Collection, 1917 (cat. 1027)

The Battle of the "Kearsarge" and the "Alabama"

Manet's canvas depicting the duel between U.S.S. *Kearsarge* and the C.S.S. *Alabama* (fig. 21) was painted quickly and placed on exhibition within twenty-six days of the naval engagement. It is difficult to judge what motivated the artist to paint this subject. The two works he sent to the Salon in May—*Incident at a Bullfight* and *The Dead Christ and Angels*—had been discussed and debated in the press.[1] The bullfight scene was criticized for gross errors of perspective and the religious subject for its lack of decorum and respect. Manet may therefore have taken an opportunity to present the proverbial man in the street with a work commemorating a recent event that had attracted much attention in the media. Manet had been strongly anti-Bonapartist since age sixteen.[2] As a member of the nineteenth-century upper-middle-class Left, Manet would have been aware of the pro-Confederate leanings of Napoleon III and that they were related to his dreams of a French empire in Mexico. Manet may also have shared the opposition's awareness that the basic issue in the American Civil War was slavery. The sixteen-year-old Manet had seen slavery in Rio in 1849 and disliked it.[3] Whatever his reasons for undertaking the work, he was also, if not primarily, challenging himself to produce a credible work of art.

By July 16 the picture was on view in one of the large windows of Alfred Cadart's print shop and art gallery near the Bibliothèque Impériale (fig. 22). Manet exhibited the picture again in his retrospective in the summer of 1867.[4] In January 1872 it was purchased by the dealer Paul Durand-Ruel, and in May it was shown at the Salon. Durand-Ruel was not listed in the program book *(livret)* as the owner, even though that was the normal practice. Neither does the painting appear on Manet's list of works valued for the January sale to the dealer.[5] One is led to wonder whether Manet was still working, or intending to work, on the canvas when Durand-Ruel decided to acquire it and the dealer agreed that the artist could retain the work until the Salon closed. Although there can be no certainty at present about the extent or timing of Manet's several interventions on the painted surface, by May 1872 the picture had surely reached its final form.

The striking composition, boldly painted in a rich but narrow range of colors, is highly unorthodox. There is no single, central focus. The artist places a number of ships over and around a great expanse of sea that rises up to fill almost three-quarters of the canvas. The viewer seems to be suspended above the waves, as if on a tall ship from which he or she looks down at the small boat advancing from lower left toward the disabled *Alabama*. There is no evidence that Manet ever visited Cherbourg, as noted earlier, but he could have

Fig. 22. **MARTIAL (ADOLPHE-THÉODORE-JULES MARTIAL POTÉMONT).**
Headquarters of the Société des Aqua-fortistes (Siège de la Société des Aqua-fortistes), 1864. Etching, plate 11 $^7/_{16}$ x 15 $^1/_4$ in. (29 x 38.7 cm). S. P. Avery Collection, Miriam and Ira D. Wallach Division of Art, Prints and Photographs, The New York Public Library, Astor, Lenox and Tilden Foundations

drawn on the conflicting press reports and the numerous depictions of the event in the illustrated papers. The first French representation of the battle appeared in *L'Illustration* (Paris) on Saturday, June 25. It was drawn by Louis Lebreton (1818–1866), occasional Salon exhibitor, author of countless lithographs, and frequent contributor to *L'Illustration,* for which he drew ships and scenes of distant lands. Lebreton depicts the moment when *Alabama* has lost steam and heads under sail for shore. *Kearsarge,* in starboard profile in the middle ground, improbably flies the Confederate flag (but not the Stars and Stripes) and fires on *Alabama,* which the artist has placed in right foreground. *Alabama* has lost half its mainmast and lists badly to starboard. Waves wash over its stern, and men pile into rowboats, which seem headed toward a sailing ship on the horizon at the extreme right. Lebreton may have understood it to be *Deerhound,* but *Deerhound* was a steam yacht, and the ship on the horizon appears to have

no smokestack. The full-page engraving published in the *Illustrated London News* on the same day is far less dramatic (fig. 23). Said to be based on a sketch made on the scene by a certain James Bryant, owner of the yacht *Hornet,* it places *Kearsarge* in the center. To its left, *Alabama* sinks stern first. Two rowboats head toward *Kearsarge.* A yacht with no sails set steams from the right. The unknown artist has placed *Alabama* and the steam yacht near the vacant skyline. Although *Kearsarge* is much larger than the other two, it also seems to be very near the horizon. This compositional strategy may be intended to convince us that we are viewing the other ships from a small craft. Three-quarters of the image is empty sky.

An unsigned half-page engraving published the same day in the *Illustrated Times* (London) and reproduced, perhaps by some sort of *clichage,* on the front page of the June 30 issue of *L'Universel* (Paris) (fig. 24), turns up again, engraved from scratch, in the July 3 issue of *El Museo universal* (Madrid). Uncannily, the *Illustrated Times* engraving shows only three ships, but it reverses the positions of *Kearsarge* and *Alabama* and it rotates the central ship by perhaps 45 degrees. *Alabama* must be sinking because men descend ropes into rowboats at its bow, but *Alabama* still has steam up, and it still flies a Confederate flag. The *Kearsarge* in the *Illustrated Times* depiction has all its sails set; the historical *Kearsarge* did not. This third variation on the theme of June 19 has a less conventional sea and a more interesting sky compared to that in the *Illustrated London News.*

On Saturday, July 2, London's two leading illustrated weeklies published another three engravings between them, and three weeklies in Paris published a total four engravings. (These seven images were probably

the last that could have had an impact on the initial elaboration of Manet's painting.) The front page of the *Illustrated London News* carried a naive half-page engraving focused on the rescue operations (fig. 25). It too restricts its scope to three vessels, but here it is *Deerhound* that holds center stage, perhaps because the image is based on a sketch by Robert Lancaster, said mistakenly by the *News* to be *Deerhound*'s owner. (John Lancaster was *Deerhound*'s owner; Robert was one of his three sons.) Eight pages later an unsigned full-page engraving shows *Kearsarge* (to the left) and *Alabama* (to the right in port profile) at the height of the great naval duel (fig. 26). The *News* tells readers that the engraving is based on a "plan and information…supplied…by Mr. George T. Fullam." Fullam, an Englishman who until June 19 was one of *Alabama*'s master's mates, conveyed a boat of wounded to *Kearsarge*, informed Winslow that *Alabama* was sinking, and was allowed to assist in further rescue operations. *Kearsarge* is obscured by smoke in the engraving based on Fullam's plan and information, but *Alabama*, which resembles the *News*'s *Kearsarge* of the week before, is quite clear. The *Illustrated Times*'s full-page engraving, like that in the *News*, shows only *Kearsarge* and *Alabama*, but it reverses the positions of the two ships.

Two of the four illustrations published in Paris on the same day—an unsigned engraving on the front page of *Le Monde illustré* and an engraving signed "H. Linton" on the front page of *L'Univers illustré*—are trivial, especially the latter, which seems to mimic late-seventeenth-century Dutch models. The other two engravings—one spread across two facing pages of *Le Monde illustré*, the other on the front page of *Petit Journal illustré*—are the work of Henri Durand-Brager (1814–1879). Born near Saint-Malo on France's Normandy coast,

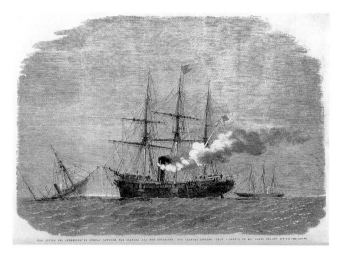

Fig. 23. "The Action off Cherbourg on Sunday between the Alabama and the Kearsarge: The Alabama Sinking.—From a Sketch by Mr. James Bryant, R.W.Y.C.," *Illustrated London News*, June 25, 1864. The New York Public Library, Astor, Lenox and Tilden Foundations

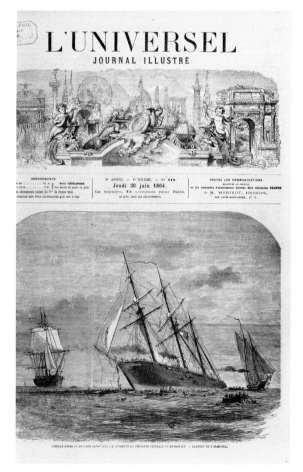

Fig. 24. Front page of *L'Universel*, June 30, 1864. "Combat entre le steamer confédéré l'*Alabama* et la corvette fédérale le *Kearseage* [*sic*]—Abandon de l'*Alabama*." Bibliothèque Nationale de France, Paris

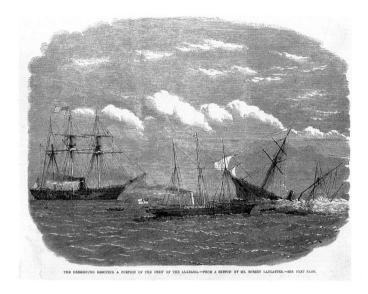

Fig. 25. "The Deerhound Rescuing a Portion of the Crew of the Alabama.— From a Sketch by Mr. Robert Lancaster," *Illustrated London News*, July 2, 1864. The New York Public Library, Astor, Lenox and Tilden Foundations

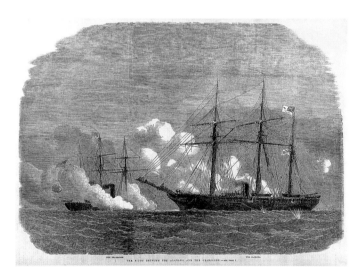

Fig. 26. "The Fight between the Alabama and the Kearsarge," *Illustrated London News*, July 2, 1864. The New York Public Library, Astor, Lenox and Tilden Foundations

Durand-Brager served in the French merchant marine before he studied painting, first with Théodore Gudin and then with Eugène Isabey. Official draftsman on *Belle Poule* during its cruise to Saint Helena to return Napoleon Bonaparte's remains to France, he accompanied several other French navy expeditions in the 1840s, sometimes as official painter. Both Paris journals identify Durand-Brager's wood engravings as "based on sketches" sent to him by their makers. The two-page engraving for *Le Monde illustré*, said to be based on a sketch by Lieutenant Lugeol, an eyewitness, places *Alabama*, seen in starboard profile, on the left; *Kearsarge*, in port profile but obscured by gunfire, is on the right.[6] (Press reports emphasized that the two ships fought starboard to starboard while they steamed in interlocking circles.) Constrained by page format, the composition of Durand-Brager's drawing for the front page of the *Petit Journal illustré*'s first issue is more conventional. We look from sea toward land. *Alabama*, in the middle ground at the left, has just been hit by the shell that tore through a boiler, and it has started to sink. Both engravings have shells striking the sea— the visual equivalent of a modern-day soundtrack. Other commonalities or tendencies among the engravings just discussed include *Deerhound* in the distance to the right, U.S. and Confederate Navy ships often seen in profile and obscured by smoke, a generally low horizon line, and, as a rule, a good deal of sky.

By July 3 Durand-Brager also had a painting of the naval duel on display in a window of the Goupil gallery at 12, boulevard Montmartre (fig. 3). That same day the history painter and journalist Charles-Olivier Merson, who had covered the 1864 Salon for *L'Opinion nationale*, reported that Durand-Brager, the painter "who knows more about the sea and ships than anyone else," had painted the bat-

tle. Merson noted Durand-Brager's visit to Cherbourg and affirmed that the "notes" on which his picture is based "have the most scrupulous authenticity." According to Merson, the picture has been on display "since yesterday" (not necessarily July 2—we do not know when Merson wrote) and that "five days ago" Durand-Brager's canvas was still blank. According to the writer for *Le Pays*, the painting represents the moment when *Alabama* receives the shot that will cause it to sink—in other words, the moment recorded in Durand-Brager's drawing for *Petit Journal illustré*. However, in the painting the artist finally got it right: *Kearsarge* and *Alabama* fight starboard to starboard. Merson wrote that Captain Winslow, who went up to Paris with three of his officers at the end of June, had seen the painting and that the Americans had complimented the artist on its "amazing exactness." Merson hastens to add that the work also has merit as art and praises "its brilliance, its effectiveness, the attractive execution, and the clever *mise en scène*."[7] In spite of the furious action, everything in Durand-Brager's picture is cool and calm, from its composition to the color scheme. The sea, its swells reinforcing the diagonal movement across the canvas and calling attention to *Alabama*'s list to port, shades from deep yet transparent tones of green in the foreground and gray in the shadows below *Kearsarge* to a luminous, creamy stretch in the distance beyond the ships. The finish is extremely smooth (more so because of strong relining), and the masts and rigging are precisely and dryly rendered.

Durand-Brager's painting did not remain at Goupil's long. Under the dateline "Paris, July 5," the *New York Herald* reported that "after exciting a good deal of attention here," Durand-Brager's painting "has been shipped to New York on speculation."[8] We do not know whether Manet had an opportunity to see it, but Durand-Brager's color lithograph of the great naval duel (fig. 27), which differs in several ways from the painting, was published in Paris by Goupil and in New York by Knoedler, and it no doubt remained available for inspection and critique long after the painting departed. Manet would have been scornful of this pleasing, "literal," and profoundly unpainterly treatment of such a dramatic subject. We cannot know whether his own decision to depict the battle was a response to Durand-Brager's challenge to bring off a similar feat against the clock. Whatever sparked his decision, Manet clearly set out to produce a vibrant, modern history painting rather than a dry, documentary account of the encounter. However useful Durand-Brager's picture and the images in the illustrated press might have been as basic material for his composition, they could provide no inspiration. For this Manet would have turned, as he customarily did at this period, to the Old Masters.

He did not lack for models in the Louvre, where a painting by Ludolf Backhuysen (1631–1708), acquired by the museum in 1816 (fig. 28), presents several striking similarities with what we now know of the origins of Manet's composition. When Manet's canvas is observed in raking light, two diagonal lines stand out in relief near the right edge, suggesting an arrangement of masts like those of the two foreground vessels on the left in Backhuysen's picture, which tilt in parallel toward the large ship as the wind fills their sails. Beneath the mastlike forms in Manet's picture, X radiography has revealed the stern of a small boat, an illegible shape above it, and another small boat—presumably a rowboat from *Alabama*—that lies beneath the present spar, in the center of the sea, to which one or two figures cling (fig. 29). Although these

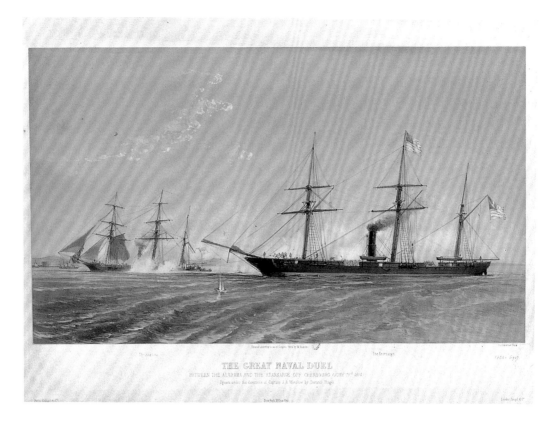

Fig. 27. **HENRI DURAND-BRAGER.** *The Great Naval Duel between the Alabama and the Kearsarge off Cherbourg (June 19th 1864),* 1864. Color lithograph, 13 x 22 $^{7}/_{16}$ in. (33 x 57 cm). Département des Estampes, Bibliothèque Nationale de France, Paris (Dc 193f)

overpainted forms are evidence of an initial search for an appropriate composition, other elements of the design were settled from the start. The boat in the left foreground, one of three pilot boats that helped to rescue the crew of the sinking *Alabama,* shows in the X radiograph as a strongly marked reserve on the canvas. In other words, its outlines were established from the start and remained virtually unchanged; the stern of the boat was altered slightly—reduced and made narrower on the left—while a looped rope below the boom of the mainsail was overpainted. A small rowboat (distinct from the present towed dinghy) may have appeared behind the pilot boat. These details, too, suggest a connection with the Backhuysen painting, in which figures in a rowboat strive to reach the strongly fore-shortened sailing vessel in the left foreground.

In Manet's painting, *Alabama* sinks by the stern in front of *Kearsarge.* Almost no in-dividual sailors are visible on the ship, in con-trast to the detailed depictions on both ships in Durand-Brager's canvas. Only at midship does a flurry of figures indicate that a crowd of men are abandoning their vessel, tumbling into a boat tossed on the waves near the inun-dated stern. Three of *Alabama's* masts are seen in reserve in the X radiograph; the Confederate flag—white with a red rectangle bearing a blue **X**—flies at the already sub-merged stern. Very rich, thick gray smoke, in

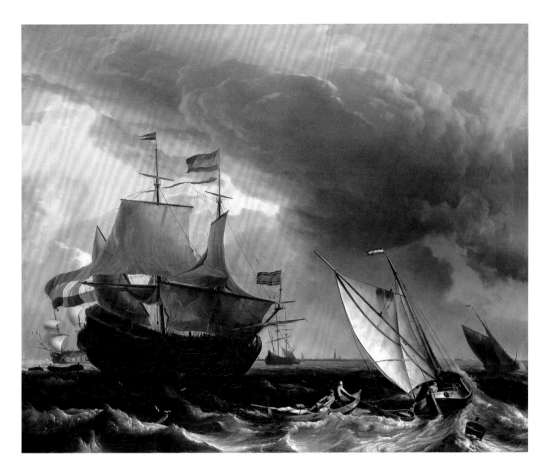

Fig. 28. **LUDOLF BACKHUYSEN.** *Dutch Ships off the Coast of Amsterdam*, ca. 1690. Oil on canvas, 26 x 31 ½ in. (66 x 80 cm). Musée du Louvre, Paris (inv. 990)

paler and darker tones, pours out of *Alabama*'s smokestack. Although the two ships are relatively far apart, the smoke from *Alabama* mingles visually on the picture surface with dark smoke from *Kearsarge*'s smokestack and white smoke from two of its guns. Smoky grays rise up to the top of the canvas against the partly cloudy sky, tying both ships firmly to the upper area of the picture. There is considerable confusion in the masts, which appear and disappear in the dark, billowing smoke, and it is impossible to clearly distinguish those that belong to one ship from those of the other. The rigging is painted with a free, thick, painterly touch that contrasts sharply

with the fine, detailed work of a professional marine painter like Durand-Brager.

To the right of the combatants, almost perched on the very high horizon line, is *Deerhound*, a prominent feature of the painting. Sharply focused, the ship has a rich, painterly quality, and its vividly colored flags—one a red ensign with a small blue area, the other a blue pennant atop the mainmast— echo the red, white, and blue tricolor and the blue and white ensign on the French pilot boat. The spectator's eye swoops and dips like a bird across the waves, looking up and out toward the distant ship, then across the great expanse of sea and down onto the flattened wake

Fig. 29. Detail, X radiograph (digital composite) of *The Battle of the "Kearsarge" and the "Alabama"* (fig. 21)

that swings in toward lower center and trails the pilot boat as it sails into the picture space over a gray foreground heaving with waves.

It is difficult to assess the significance of Manet's decision to make the pilot boat such an important feature of his picture. It may have been simply a compositional device that enabled him to set the battle back in space, thus freeing him from the demands of a detailed depiction of ships that were unknown to him. Or he may have liked the idea of an anonymous protagonist who occupies the foreground with his lifesaving craft. It does not seem likely that Manet could have identified the pilot in his painting with Antoine François Mauger, proprietor of the pilot boat *Les Deux Jeunes Soeurs*, who rescued five officers and seven members of *Alabama's* crew from drowning. The historical Mauger received a letter of thanks and twenty pounds

sterling from the officers and a second-class gold medal from the French government for his "courage and humanity."[9] The figure who stands at the tiller in shirtsleeves, black waistcoat, and top hat may not have been intended to represent a particular pilot, although his doughty presence suggests that Manet had a particular person in mind. Of the other sailors on board, one is seen to the left behind the boom (perhaps originally placed in front of it), and another wearing yellow oilskins stands at the starboard edge preparing to throw a line to the figures clinging to a spar in the water, near the center of the picture. A sailor stands on the foremast boom, tying a reef or preparing to climb the mast, as a lookout stands in the bows.

The composition is organized around an expanse of empty sea, and the combat takes place far out in an area that is visually connected with the horizon. Sails and smoke are dramatically backlit, and the near sides of the waves are in shadow. These details create a particularly intense tonal and coloristic effect in which somber zones are contrasted with vividly luminous and atmospheric areas. Manet evidently intended the action to be "viewed" as if looking out to sea, with the pilot boat sailing from Cherbourg toward the fighting ships. No land is visible in the background, and *Deerhound,* with its engines belching smoke, ready to go full steam ahead, is positioned in a place appropriate to its subsequent flight to the English coast with its cargo of captain, officers, and crew from *Alabama.* The horizon is unnaturally light, its line choppy and uneven, suggesting the extent to which Manet adjusted this area as he worked. A flurry of white cloud rises over *Deerhound,* and blue sky emerges from the gray smoke and clouds at the top of the canvas. *Kearsarge* is all but invisible behind *Alabama,* and it is possible that Manet delib-

erately refrained from defining the victorious ship, whose precise shape he did not know. In a note to Philippe Burty, Manet says that he "made a pretty good guess" (see fig. 33).[10]

The painting as we see it now is a "finished" and very impressive work in terms of Manet's oeuvre. Technical investigation does not allow, at least at present, more than speculation about the time frame of Manet's development of the painting. It would appear that the stronger tones of turquoise green may have been added after Manet's experience of the sea at Boulogne later that summer. And one may surmise that the choppy, broken, and much lighter horizon was the result of later repainting. But we cannot yet "rebuild" the original composition suggested by underlying forms that appear in the X radiograph, nor can we determine whether Manet might have reworked his picture on more than one occasion, such as for his retrospective in 1867 or again in 1872 before he exhibited the work at the Salon. All we can say at present is that Manet's depiction of the sinking of *Alabama* may have looked rather different when first displayed in Cadart's window in July 1864.

NOTES

1. Gary Tinterow and Geneviève Lacambre, *Manet/Velázquez: The French Taste for Spanish Painting,* exh. cat., Musée d'Orsay, Paris, and The Metropolitan Museum of Art (New York: The Metropolitan Museum of Art; New Haven: Yale University Press, 2003), nos. 141, 142.

2. Édouard Manet, *Lettres de jeunesse, 1848–1849: Voyage à Rio* (Paris: Louis Rouart et Fils, 1928), pp. 60, 64. 67.

3. Ibid., pp. 52, 58, 62.

4. Catalogue des tableaux de M. Édouard Manet exposés avenue de l' Alma en 1867, exh. cat. (Paris 1867), no. 22, *The Combat of the American Ships "Kersearge" [sic] and the "Alabama" (le combat des navires américains "Kersearge" et "Alabama").*

5. Manet sold the work to Durand-Ruel for three thousand francs (Paris stock, no. 962), along with twenty-four other paintings from his studio. In May, it was catalogued as no. 1059 in the Salon *livret.*

6. *Le Monde illustré,* July 2, 1864, p. 10. Henri-Gustave-Alphonse Lugeol (b. 1836) had entered the navy in 1851 and accompanied Napoleon III as a draftsman-reporter on an official visit to Algeria in 1865, when his drawings were lithographed by Kerjean for reproduction in the *Revue maritime et coloniale. Revue maritime et coloniale* 15 (October 1865), between pp. 256 and 257. He may also have supplied the drawing from which Kerjean composed a lithograph of the battle between *Alabama* and *Kersearge* for the same official publication. *Revue maritime et coloniale* 11 (August 1864), between pp. 828 and 829.

7. Charles-Olivier Merson, untitled text, *L'Opinion nationale,* July 3, 1864, p. 2.

8. "Our Paris Correspondence," *New York Herald,* July 18, 1864, p. 8.

9. For the letter of thanks, see Bourgogne, "L'Alabama," *Phare de la Manche,* June 22 [in error for June 21], 1864, p. 2, repeated in *La Patrie,* June 23 (p. 2) and *La Nation,* June 24 (p. 2). For the twenty pounds sterling, see "Chronique locale," *Phare de la Manche,* July 19, 1864, p. 2, and "Chronique locale," *La Vigie de Cherbourg,* July 21, 1864, p. 3. (Mauger divided the money among his crew.) For the medal, see "Chronique locale," *La Vigie de Cherbourg,* July 28, 1864, p. 3.

10. "Je l'avais assez bien deviné."

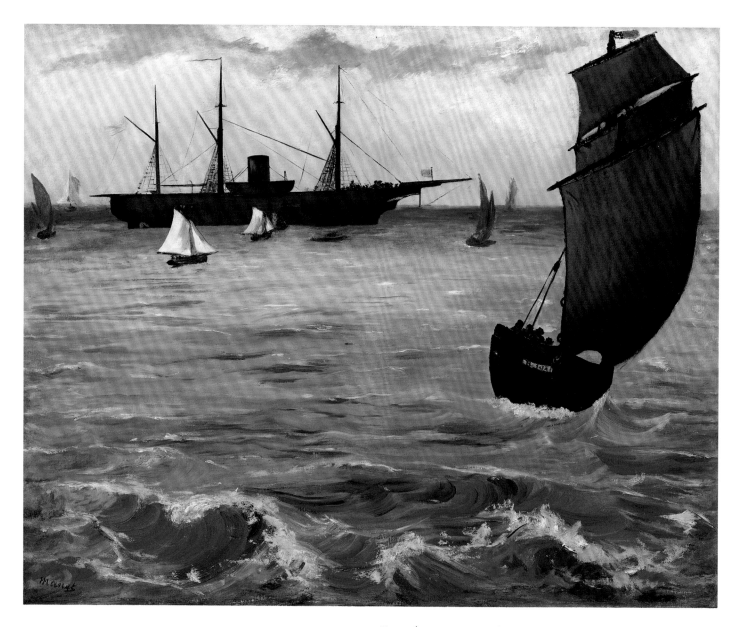

Fig. 30. **ÉDOUARD MANET**, *The "Kearsarge" at Boulogne*, 1864. Oil on canvas, 32 1/8 x 39 3/8 in. (81.6 x 100 cm). The Metropolitan Museum of Art, New York, Partial and Promised Gift of Peter H. B. Frelinghuysen, and Purchase, Mr. and Mrs. Richard J. Bernhard Gift, by exchange, Gifts of Mr. and Mrs. Richard Rodgers and Joanne Toor Cummings, by exchange, and Drue Heinz Trust, The Dillon Fund, The Vincent Astor Foundation, Mr. and Mrs. Henry R. Kravis, The Charles Engelhard Foundation, and Florence and Herbert Irving Gifts, 1999 (1999.442)

The "Kearsarge" at Boulogne

U.S.S. *Kearsarge* (fig. 31) visited Boulogne five times in 1864 for periods ranging from two to twelve days. On all five occasions it anchored in the roads—that is, in "safe" water some distance from the port and town. The ship's log gives us some sense of where it anchored, and the diaries of *Kearsarge* crew members tell us what they saw of Boulogne and, to some extent, what the townspeople saw of the crew and the ship.[1]

Even before its victory over *Alabama*, *Kearsarge* was the object of much interest among locals on both sides of the English Channel. As officer's cook Charles Fisher wrote on February 25, 1864: "Anchored off the Town of Dover at twelve. This is the first time we have anchored off any town in England and we are as much surprised at the people as they are at us, for ours is the first American steamer that ever anchored off the town...We are perfect curiosities. A crowd of Ladies, gentlemen and working men and women gathered on the pier...and as soon as we landed they fell back like we were the plague. Where is the butcher[']s? I enquired advancing on one of the men. Oh! Why he speaks English said a woman making tracks. They have never seen Yankees before and some of the most intelligent have always thought us barbarians...." The following day, when the ship was off Boulogne, Fisher continued, "I went to market in the second cutter...my first impressions were very favorable...We are as much a show here as we were at Dover and crowds gather around the Doctor, Purser and myself who have the honor to be the first representatives ashore of our ship[']s company."[2]

The interest in *Kearsarge* was a boon to the owners and operators of small craft (fig. 32). The twenty-four-hour rule prevented *Kearsarge* from docking. Officers and crew members who had business on shore could use one of *Kearsarge*'s several boats, but civilians either had to own their own or rely on others. Marine Corporal Austin Quinby noted in his journal of a day spent in the waters off Dover that "the boatmen are reaping a great harvest some of them make 5 [pounds] a day in carrying pas[s]engers...."[3] Given the numbers of visitors reported in the *Kearsarge* crew journals, the same conditions prevailed in France. Many of the visitors were content simply to circumnavigate the great warship, while others wanted to set foot on board. British and French naval officers clearly had a professional interest in the vessel or in particular features, such as the Dahlgren guns.[4] However, most visitors seem to have been driven only by curiosity, and they were willing to brave choppy seas and the messy details of life on a sloop of war in order to satisfy it. As William Wainwright, a coal heaver on *Kearsarge,* observed: "A boat came along side with a number of Ladies in it. they didn[']t want to let

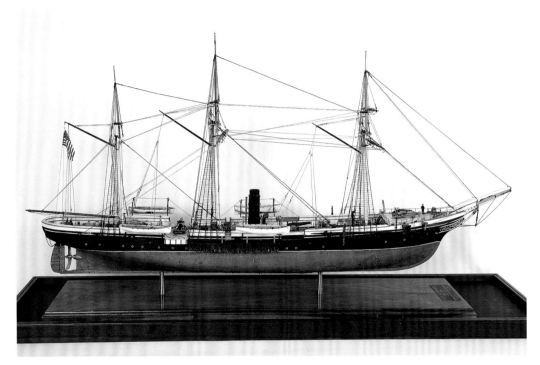

Fig. 31. Model of U.S.S. *Kearsarge,* constructed by Dr. Arthur C. Roberts, 1992–97. Basswood, holly, and other woods, metal, and other assorted materials, 24 x 50 ½ x 12 ¾ in. (61 x 128.3 x 32.4 cm); scale ³/₁₆ in.: 1 ft. Maine Maritime Museum, Bath (MMM98.069)

them aboard owing to the decks being dirty and wet. but it was no use. they was bound to come aboard. they said that they was afraid we should go to sea to night and they would have no chance. this is the first time an american man of war was here and [as] a matter of course it creates quite an excitement."[5] Crew members were happy to have visitors, as Wainwright explained in his journal: "It is a little change for us. for we have the same chance of showing them round the ship that the Officers have. some one must show them round, and there is not officers enough to show one half of them...."[6] Indeed, the crew was especially fond of female visitors and—if their journal entries can be trusted—they enjoyed flirting with them, even if the visitors did not speak English or had outlandish ideas about America: "Just as everything was swim-

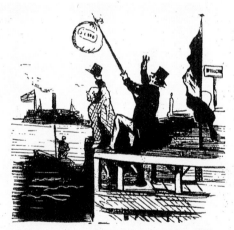

Dans le but d'attirer les curieux parisiens, les différens ports offrent une prime aux bâtimens de guerre américains qui voudront bien se battre dans leurs parages.

Fig. 32. **CHAM (AMÉDÉE DE NOÉ).** Caricature from "Croquis," published in *Le Charivari,* July 3, 1864. "In the hopes of attracting curious Parisians, various ports offer a subsidy to American battleships that wish to fight in their vicinity."

Fig. 33. Letter from Édouard Manet to Philippe Burty, undated (ca. July 18, 1864). Written from Boulogne-sur-Mer. Bibliothèque d'Art et d'Archéologie, Fondation Jacques Doucet, Paris

ming in water and there was about a foot on the decks along come boat loads of visitors. Old man Sumner [Acting Master David H. Sumner] told them and begged them not to come aboard, but it was no use, come they would in spite of everything he could say. Over the gangway they came and Oh My, what nice times our boys had scattering around the water to make them show their pretty legs."[7]

In thanking critic Philippe Burty for the good word that he had printed about *The Battle of the "Kearsarge" and the "Alabama"* in an issue of *La Presse*, Manet wrote that he had visited *Kearsarge* "last Sunday" (fig. 33). The verb that Manet uses—*visiter*—normally means, when the direct object is a ship, that the subject boarded or set foot on the vessel. Monday issues of *La Presse* were printed and placed on sale the preceding Saturday evening,

so if Manet had been in Paris on Saturday, July 16, he could have read the July 18 issue that evening. But he was in Boulogne, which was five and a half to seven and a half hours from Paris by rail. If copies of Monday's *La Presse* were loaded on the train that left Paris at 10 P.M. Saturday night, Manet might well have been reading it on Sunday morning. If this was the case, and if Manet scribbled his note to Burty on the spot, "last Sunday" would mean July 10. The *Kearsarge* log for that day records: "At 6.51 [P.M.] let go Port anchor in Boulogne roads, 7 fathoms water, veered to 30 fathoms chain" (fig. 34)[8]. If we rely on crew journals, however, the people who boarded the ship then did so mainly on Monday.[9]

For the following Sunday, July 17, the ship's log record's that *Kearsarge* anchored in Boulogne roads at 12:50 P.M. Saturday, and

Fig. 34. Log of U.S.S. *Kearsarge*, vol. 3 (February 27–November 26, 1864),
shown open to July 10, 1864. National Archives, Washington, D. C.

that it did not leave Boulogne until 8:45 P.M.
Sunday. Wainwright wrote, "There [h]as been
a great many visitors on board to day but they
are mostly frenchmen so there is not pleasure
in their company. they go up and down the
decks chattering away like so many monkeys,
and they go through as many antics as I ever

see a Clown go through in a circus...." Quinby
was less critical: "The ship is pretty well
crowded with a fine lot of people many of
them from the country and have on their
Sunday go to meeting cloth[e]s and are very
nice looking...."[10] Clearly, Manet would have
had considerably more time to visit *Kearsarge*

on July 17. In any case, if Manet did indeed set foot on the ship, as his note to Burty suggests, he would have approached the ship by sea and would have had ample opportunity to study *Kearsarge* in relation to the sea and other vessels.

Manet depicted *Kearsarge* at anchor off Boulogne in at least two works. One is an ink-and-watercolor drawing (fig. 35). The other is an impressive oil painting on canvas, which shows *Kearsarge* at anchor some distance away across a wide expanse of sea, a dark silhouette against a backdrop of clouds, surrounded by a flotilla of small craft. The painted surface of the latter work, *The "Kearsarge" at Boulogne* (fig. 30) divides visually into four horizontal bands of roughly equal height. The lowest band is entirely occupied by a swelling sea painted with brushstrokes of bright, strong blue and gray mixed on the palette and applied to the predominant deep green. In the foreground two arcs of white foam suggest invisible currents that seem to be pushing the water in opposite directions. The band immediately above this has the same highly saturated palette, but here the surface of the sea is relatively smooth. The swelling sails of the smaller vessels and the flags of *Kearsarge* clearly indicate that the wind is blowing or gusting quite briskly, yet on the sea it registers only as thin, short, white, nearly horizontal strokes. The most notable feature of the second band is the fishing boat near the right edge—the indistinct number on its bows no doubt registered with the port authorities at Boulogne—that speeds toward us and that provided Manet with the title he later gave the picture: *Fishing Boat Coming in Before the Wind (Bateau de pêche arrivant vent arrière).*[11] The boat's brown sails contrast with the green water and effectively balance *Kearsarge,* the other large vessel in the picture—brown against black, vertical against horizontal. In the third band the water lightens noticeably, and the dominant green yields to blue. Manet places *Kearsarge* near the top edge of this third band, which also sports a number of small craft—three or four directly in front of *Kearsarge* and four flanking sailing ships, two on either side, one nearer, one farther. The large ship and the smaller ones are placed so as to suggest depth and distance within the picture, but they also provide a counterbalance on the picture plane to the fishing boat, which is such a prominent feature on the right. The fourth band depicts the sky above the sea, much of it covered by bright white clouds that turn gray toward the horizon, but glimpses of unclouded sky are a sweet, gentle, uncomplicated light blue.

Repeating the innovative compositional strategy of *The Battle of the "Kearsarge" and the "Alabama"* (see fig. 21), for which he had to use his imagination to paint both ships, Manet pushes the nominal object of interest up and away from the center of the picture. *Kearsarge*'s profile stands out against the sky, its darkness emphasized by the white clouds massed above the horizon. By representing *Kearsarge* in profile, Manet followed what seems to have been standard practice in the branch of marine painting concerned specifically with ship portraiture. Compared with the atmospheric, painterly rendering of the ships in the *Battle,* Manet's portrayal of *Kearsarge* at anchor off Boulogne is somewhat stiff, perhaps even naive. His depiction of its bows and bowsprit, smokestack, masts, and rigging is relatively painstaking, and the uniform dark gray of the hull is unaffected by the play of light on the water.

In his note to Philippe Burty, Manet wrote not only that he had been to see *Kearsarge* but that he had "painted...the way

Fig. 35. **ÉDOUARD MANET.** *The "Kearsarge" at Boulogne*, 1864. Watercolor, 10 x 13 ¹/₄ in. (25.5 x 33.5 cm). Musée des Beaux-Arts, Dijon (2959E)

it looks at sea."[12] This statement has been interpreted as meaning that the oil painting *The "Kearsarge" at Boulogne* was done that summer in Boulogne, but that is open to question. It is usually assumed that the painting was preceded by the ink-and-watercolor drawing and that the drawing was made in front of the subject. For the drawing Manet used a strong textured paper of the kind favored by watercolorists, and, if we did not know that *Kearsarge* was at least a mile from shore when it visited Boulogne, we might suppose that Manet had painted it from one of the piers. Nevertheless, the drawing, however quickly it was executed, makes a strong compositional statement that is already very close to that of the painting. The off-center placement of the

large ship is balanced on the sheet by a comparable weighting of the design on the right. Moreover, the sailing ship to the left of *Kearsarge* ("cut" by the left edge of the paper) is unrealistically large in relation to the warship, which suggests that Manet "imported" it from another source. One may question whether the artist could at one time have captured the details of the ship that he intended to portray on canvas and have reached an almost final understanding of its bold and unusual composition.

A knowledge of Manet's working methods suggests that he would have made several drawings in a sketchbook capturing the appearance of the ship and from a variety of viewpoints. He would also have noted all the

different types of small craft that he encountered around it for use as staffage in his picture. It would be logical to suppose that the watercolor (which shows no signs of underdrawing) was painted from lost pencil sketches and that he used them for the other vessels in the painting. When the watercolor drawing was photographed in Manet's studio after his death in 1883, it already had the blot at upper left that someone, perhaps the artist, had attempted to remove.[13] The watercolor drawing may have suffered an accident, perhaps from a drop of oil that stained the paper, when it was used as an aide-mémoire for the painting. One may note that a thin filament of what appears to be oil paint lies on the surface of the paper in the area of the sky.

There is another indication that Manet's watercolor was not a direct observation but that it was based on more or less accurate sketches. François Rondin photographed *Kearsarge* in Cherbourg roads after the battle and made the resulting "portrait" a carte de visite photograph, which Rondin incorporated into his montage *Mosaïque du Kearsarge* (figs. 36, 37). The photograph highlights the sleek lines of the low-lying warship and the pattern of its rigging. Although Rondin and Manet show the ship in the same starboard profile view, the outlines of bow and stern in the photograph differ from those seen in the watercolor, as does the rigging and the smokestack, which is noticeably taller and narrower. These differences are even more marked in the painting, where the smokestack is as squat and thick as that of a toy boat, while the silhouette of the launch suspended from davits is transformed visually into the toy boat's hull. Although *Kearsarge*'s smokestack could be retracted, which means that it could have varied in height from day to day, it was never as broad at its base nor was the launch ever

Fig. 36. **FRANÇOIS SÉBASTIEN RONDIN.** *Le Kearsarge,* 1864. Albumen silver print, image 2 ⅝ x 3 ¾ in. (6.7 x 9.5 cm). Library of Congress, Washington, D.C.

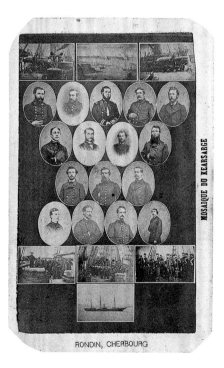

Fig. 37. **FRANÇOIS SÉBASTIEN RONDIN.** *Mosaïque du Kearsarge,* 1864. Albumen silver print, image 3 ¾ x 2 ¼ in. (9.5 x 5.7 cm). Library of Congress, Washington, D.C.

as bulky as Manet depicts them. (It is very unlikely that Manet saw and used Rondin's photograph.)

In the oil painting, *Kearsarge* is even less true-to-life than it is in the watercolor, where the ship is still relatively slim and "racy." As for the small craft that surround the warship, the single sail to the right of *Kearsarge* in the drawing becomes the more detailed depiction of a brown-sailed fishing boat in the painting; the large sailing boat at the left edge and the small squat shape by *Kearsarge*'s stern, possibly a rowboat, are replaced by two smaller sailing ships, while two white-sailed boats head purposefully toward the warship, perhaps carrying some of the visitors who thronged to see *Kearsarge* during its stay at Boulogne. The squat, almost indecipherable shape of a rowboat in the right foreground of the watercolor is in the painting enlarged and connected with the shape of the sailing vessel above it to form the fishing boat "coming in before the wind" that anchors the composition on the right.[14]

Kearsarge spent the last twelve days of June and the first five days of July 1864 anchored on the land side of Cherbourg's breakwater—near the west end, rather close to that formidable structure—and it seems likely that Rondin positioned himself and his apparatus on the breakwater in order to take his profile photograph. Manet's contemporaries remarked on *Kearsarge*'s notably black hull, which Manet softened into a uniform dark gray.

Kearsarge was in fact rather remarkably black. In July 1862, John Lenthall, chief of the U.S. Navy's Bureau of Construction and Repair, ordered all U.S. Navy vessels to be painted a particular bluish gray color that, it was felt, would help to conceal them both in daylight and at night. U.S. Navy headquarters in Washington distributed samples of the paint and a formula for its composition to the heads of U.S. Navy shipyards.[15] *Kearsarge* sailed five and a half months before Lenthall issued his order, however, and both Captains Pickering and Winslow were evidently unaware of it. The ship's log records that considerable quantities of black paint were taken on board during its thirty-three-month first cruise, and crew journals record several painting sessions.

The *Kearsarge* crew seems to have felt that the ship's black silhouette set it apart from other vessels, and the nicknames they bestowed on it—"the Stovepipe Black cruiser of the Isle," "the Black Spirit of the Western Isles"—reveal that its distinctive appearance was an important element in the pride that they took in their ship.[16] What *The "Kearsarge" at Boulogne* may lack in literal accuracy it makes up in its striking composition, with the victorious Federal sloop riding the waters off Boulogne, flags and pennants flying in the stiff wind that speeds a local fishing vessel toward land. Manet's completed painting offers an impressive view of the victor of the battle at Cherbourg as it lay on a more lifelike, yet still conventional, sea.

NOTES

1. Four men kept journals that are complete for the length of *Kearsarge*'s first campaign. The unpublished manuscript journals of coal heavers Charles A. Poole and William Wainwright are in the G. W. Blunt White Library, Mystic Seaport, Mystic, Connecticut (Log 432 and Log 429, respectively). The unpublished manuscript journal of U.S. Marine Corporal Austin Quinby is in the Phillips Library, Peabody Essex Museum, Salem, Massachusetts. The journal of officer's cook Charles B. Fisher—one of *Kearsarge*'s African-American crew members— has been edited by Paul E. Sluby Sr. and Stanton L. Wormley and published as *Diary of Charles B. Fisher* (Washington, D.C.: Columbian Harmony Society, 1983); the manuscript is on deposit at the library of the U.S. Army Military History Institute, Carlisle Barracks, Carlisle, Pennsylvania.

2. Fisher, *Diary,* pp. 64–65.

3. Austin Quinby, July 14, 1864.

4. Charles A. Poole, March 2, 1864; Austin Quinby, March 2, 1864; Fisher, *Diary,* pp. 65–66 (February 27–28, 1864).

5. William Wainwright, March 2, 1864.

6. William Wainwright, July 13, 1864.

7. Charles B. Fisher, March 2, 1864.

8. U.S.S. *Kearsarge* log, July 10, 1864, National Archives, Washington, D.C.

9. Poole, Wainwright, and Quinby, July 11, 1864. Fisher seems to be off by one day in his July 1864 entries.

10. Wainwright, Quinby, and *Kearsarge* log, July 17, 1864.

11. For a discussion of the painting's title, see "Manet's 1864 Boulogne Seascapes," in this volume, pp. 61–71.

12. "J'en ai peint du reste l'aspect en mer." See Manet to Burty, Étienne Moreau-Nélation, *Manet raconté par lui-même,* 2 vols. (Paris: Henri Laurens, 1926), vol. 1, p. 61.

13. The drawing was listed by Léon Leenhoff in his register of works in Manet's studio under number 235 as *Marine Aquarelle,* with the indication that it was framed and had been photographed. The photograph by Lochard, annotated by Leenhoff, is in one of three such albums in the Pierpont Morgan Library, New York (Tabarant albums, vol. 1, p. 78). Leenhoff identified it only as a steamboat (*bat[eau] à vapeur*). The blot, and also the overmounting of the edges of the design, led to a later misreading of the distant shape at the left edge as a fort when it is clearly a ship in full sail; see Françoise Cachin et al., *Manet, 1832–1883,* exh. cat., Galeries Nationales du Grand Palais, Paris, and The Metropolitan Museum of Art (New York: The Metropolitan Museum of Art, 1983), p. 224, no. 85.

14. X radiography of the painting reveals very few alterations to the initial composition, in which the silhouettes of *Kearsarge* and the sails of the fishing boat to the right are clearly marked in reserve on the canvas. There is, however, an indication that the shape of the fishing boat's hull may have been substantially enlarged.

15. Richard E. Winslow III, *Constructing Munitions of War: The Portsmouth Navy Yard Confronts the Confederacy, 1861–1865* (Portsmouth, N.H.: Peter E. Randall, 1995), pp. 111, 348.

16. Austin Quinby, April 18, 1864 (Ostend), and June 19 (Cherbourg); Charles B. Fisher, February 29, 1864 (Boulogne), March 12 (Margate), March 31 (London), April 19 (Ostend), May 7 (Flushing [Vlissingen]), and June 22 (Cherbourg).

Fig. 38. Map of Boulogne-sur-Mer, 1865. Lithograph, 31 ⁷/₈ x 40 ¹/₈ in. (81 x 102 cm). Bibliothèque Municipale, Boulogne-sur-Mer

Manet's 1864 Boulogne Seascapes

In April 1864 the Établissement des Bains—the municipal enterprise that ran the large building and gardens devoted to bathing and leisure activities in Boulogne-sur-Mer (fig. 39)—published an illustrated pocket guide and program for the season.[1] The preface describes Boulogne, which had more than thirty-six thousand inhabitants, as the largest town in the Pas-de-Calais area. "Its wide streets flanked by handsome sidewalks paved with marble, its elegant houses, its magnificent quays, make it an exceptionally agreeable holiday destination. Its picturesque walks, its busy port, its historic monuments, its well-stocked library, its splendid museum, etc., ensure that visitors from out of town will enjoy a delightful stay."[2] For their 1864 summer stay in Boulogne, the Manet family did not take rooms in one of the hotels advertised in the guide, nor did they stay in one of Boulogne's elegant houses. They rented a small house in 10, rue de l'Ancienne Comédie, a narrow street near the town center. The house did not overlook the port, and it had no view of the sea. Its purpose was evidently to satisfy the family's daily domestic needs.[3]

The Manets looked elsewhere for amenities and distractions. We do not know exactly when they arrived in Boulogne, but it was probably on or shortly before Saturday, July 16, when they purchased a one-month "subscription" at the Établissement des Bains.

The beach club had family rates, and the Manets' subscription was for a family of five: the artist, his wife, his mother, his younger brother Gustave, and a Madame Leenhoff, perhaps his wife's sister or mother.[4] The subscription gave the visitors access to "all parts of the garden and terrace, the saloons, the grand balls, children's balls, *soirées dansantes,* musical and dramatical, and all the amusements of the Établissement."[5] While the ladies might be content to stroll in the gardens or sit watching children at play, Manet "took baths" and probably experienced the Channel waters from a bathing-machine—a horse-drawn cabin on wheels that an attendant led into the sea until the bathers occupying it could slip discreetly into the waves and then clamber back to the comfort of dry towels and shelter from the sea breeze (fig. 40). Bathing-machines could be hired, and a swimming pool with cold seawater was available on the grounds of the Établissement, which also offered a tariff for hot seawater baths and indoor showers.[6] Writing to his friend and fellow artist Félix Bracquemond in Paris, Manet remarked that his "sea baths" *(bains de mer)* were beneficial, but he regretted the separation from his usual Parisian haunts, the Café de Bade and "discussions on Art with a capital A."[7]

Judging from his letters and the remarks of his contemporaries, Manet was a restless man who quickly became bored, espe-

THE NEW BATHING ESTABLISHMENT AT BOULOGNE-SUR-MER.

BAINS DE MER, LA PLAGE DU CROTOY (Somme).

Fig. 39. "The New Bathing Establishment at Boulogne-sur-Mer," *Illustrated London News*, July 11, 1863. The New York Public Library, Astor, Lenox and Tilden Foundations

Fig. 40. "Bains de mer, la plage du Crotoy (Somme)," *L'Universel,* June 30, 1864. Bibliothèque Nationale de France, Paris

cially when away from Paris. It is likely that he soon set off to explore Boulogne on his own and to sketch the port, the beach, and ship traffic in the Pas de Calais, or Strait of Dover, from any vantage points that he could find. The land rises steeply behind the port and beach at Boulogne, and the old walled town is perched high above the "new" one. In the nineteenth century, many vantage points provided

Fig. 41. **ÉDOUARD BALDUS.** *Entrée du Port de Boulogne (Boulogne: The Port Entrance)*, 1855. Salted paper print, 11 5/16 x 17 1/8 in. (28.8 x 43.5 cm). The Metropolitan Museum of Art, New York, Louis V. Bell Fund, 1992 (1992.5000)

Fig. 42. **CHARLES GRASSIN.** *Le quai Gambetta, Boulogne-sur-mer*, ca. 1880–83. Gelatin silver print(?), 7 5/8 x 9 7/8 in. (19.3 x 25 cm). Château-Musée de Boulogne-sur-mer

Fig. 43. **CHARLES GRASSIN.** *Vapeur de Folkestone et chalutier à voile, Boulogne-sur-mer*, ca. 1881–83. Gelatin silver print(?), 7 3/4 x 10 in. (19.8 x 25.5 cm). Château-Musée de Boulogne-sur-mer

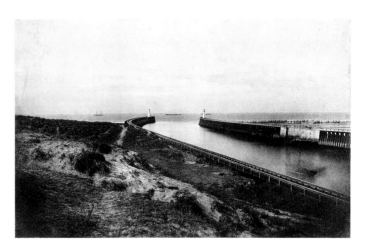

views, as they still do today, of the beach and the port.[8] In the latter, with its various docks for steamers, fishing boats, and commercial vessels, there was constant movement; small and large craft came and went along the broad channel between the two piers or jetties that are a dominant feature of the harbor town (figs. 41, 42). Manet would have seen fishing boats of greater or lesser size, side-wheel steamers setting out for Folkestone or London (fig. 43), pleasure craft, even the two-cent ferry that took people across the stretch of water separating the channel's two parallel piers. Each pier was a popular promenade. The longer, southwestern pier was accessed from the quays around the floating dock, near the railway station and abutting the industrial area known as Capécure, which was dominated by the dune de Châtillon. This great sand dune provided superb views over the town, the port, and the piers. The northeastern pier led from the quay where the steamers docked and abutted the Établissement des Bains and the beach. Both piers were the subject of paintings and watercolor sketches by Manet (see fig. 62).

These were the active, urban aspects of the port of Boulogne. For undisturbed views of ships at sea, Manet could walk to the end of

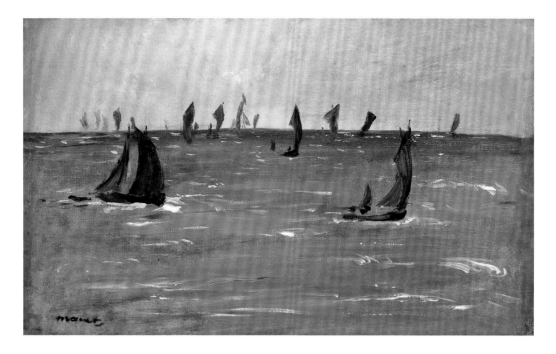

Fig. 44. **ÉDOUARD MANET.** *Sailing Ships at Sea*, 1864–68. Oil on canvas, 13 ³/₈ x 22 in. (34 x 55.8 cm). The Cleveland Museum of Art, Purchase from the J. H. Wade Fund (1940.534)

the piers, climb the dune de Châtillon, or stroll the cliffs north of town that continue on toward Cap Gris-Nez. Winding roads led up to the high ground overlooking the beach, from which Napoleon had proposed to send a huge army against Great Britain in 1804. For views across the Channel to the English coast, the Boulogne guidebooks recommended an hour-long walk to Napoleon's Column, an immensely tall commemorative monument constructed higher up and farther inland between 1804 and 1841. From the cliff tops above the beach Manet could enjoy magnificent views of the sea, its surface ruffled by waves on breezy days or limpid and stained with deep, clear colors in calm weather. The artist's paintings and drawings reflect the many moods of the sea and the great variety of ships that sailed or steamed in the waters off Boulogne in the years from 1864 to the end of the decade.

On the afternoon of July 16, 1864, U.S.S. *Kearsarge* anchored in Boulogne roads. On the following day it seems likely that Manet sailed out to the ship and went on board. Writing to Bracquemond in Paris, Manet commented that since arriving in Boulogne he had "done some studies of small boats on the open sea."[9] Pictures that correspond to this description are known, but their date is uncertain, and they may belong to the period of Manet's visit to Boulogne in 1868 (fig. 44). The chronology of the seascapes is difficult to establish. This was a minor genre, and while most of Manet's seascapes are signed—proof no doubt that they were sold in his lifetime—almost none are dated. Only the *Battle* and *The "Kearsarge" at Boulogne* can be securely dated, the former to late June or early July 1864, the latter to late summer or perhaps autumn of the same year. The *Battle* was a studio invention, and, as we have suggested, the "portrait" of *Kearsarge* at

Fig. 45. **G. RANDON.** Caricature from "L'Exposition d'Édouard Manet," published in *Le Journal Amusant*, June 29, 1867. "The Battle of the American Ships *Kerseage* [sic] and *Alabama*. I am not opposed to it, but this could just as well depict herrings being grilled on two boats from Saint-Cloud."

Fig. 46. **G. RANDON.** Caricature from "L'Exposition d'Édouard Manet," published in *Le Journal Amusant*, June 29, 1867. "Fishing Boat Coming in Before the Wind. What on earth would drive an artist to paint and, more important, to show us such a production when nothing forces him too."

Fig. 47. **G. RANDON.** Caricature from "L'Exposition d'Édouard Manet," published in *Le Journal Amusant*, June 29, 1867. "Steamboat (Seascape), or steam-powered navigation in a plate of sorrel purée."

LE COMBAT DES NAVIRES
AMÉRICAINS *KERSÉAGE*
ET *ALABAMA*.

Je ne m'y oppose pas, mais ce pourrait tout aussi bien être deux bateaux de Saint-Cloud où l'on fait cuire des harengs sur le gril.

BATEAU DE PÊCHE ARRIVANT
VENT ARRIÈRE.

Quel diable peut donc pousser l'artiste à faire et surtout à nous montrer des machines comme ça, quand rien ne l'y oblige?

LE STEAM-BOAT (MARINE),
ou la vapeur appliquée à la navigation
dans un plat d'oseille.

Boulogne was very possibly painted in Manet's studio on his return to Paris in September 1864. Indeed, it is probable that Manet, rather than painting in a makeshift studio in his rented house, let alone in the open air, executed all the canvases connected with his 1864 Boulogne holiday in his Paris studio using notations *(croquis)* made in sketchbooks or from watercolor studies *(études)*.

Three documents help us to identify seascapes related to Manet's 1864 visit to Boulogne. The first is a note Manet sent to Louis Martinet in early 1865; it lists eight works he intended to send to a group show at Martinet's gallery. One work—number 8—is titled simply "la mer" (the sea). Its subject is not specified; it could have been one of two other seascapes that were shown in Manet's retrospective exhibition in 1867 (not including the *Battle*) or another picture altogether of whose sale no early record has survived. The other work—number 7—is titled "la mer (le navire federal Kearsage [sic] en rade de Boulogne-sur-mer" (the federal ship *Kearsarge* in the roads at Boulogne-sur-Mer).[10]

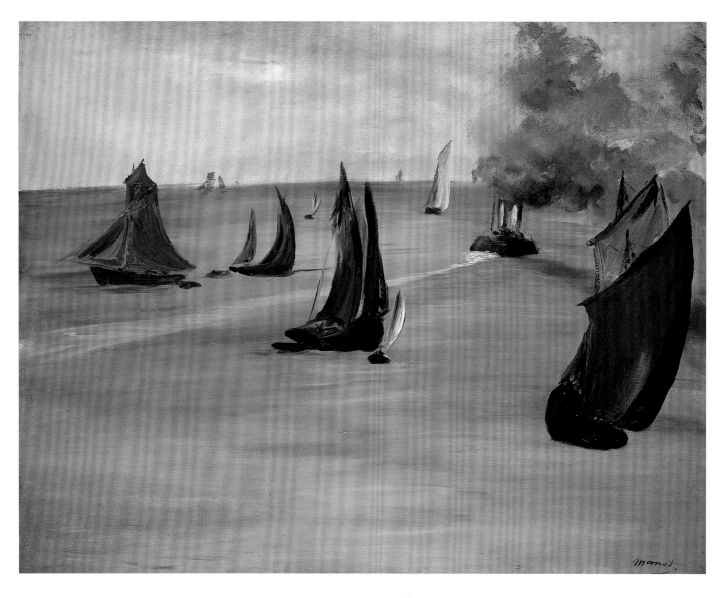

Fig. 48. **ÉDOUARD MANET.** *Steamboat Leaving Boulogne*, 1864. Oil on canvas, 29 x 36 ½ in. (73.6 x 92.6 cm). The Art Institute of Chicago, Potter Palmer Collection (1922.425)

The other documents are the catalogue that Manet had privately printed to accompany his retrospective exhibition in Paris, held in a custom-built pavilion near the Pont de l'Alma from late May through July 1867, and a set of sixteen caricatures of works in the show that was printed in a comic illustrated weekly (figs. 45–47). The exhibition included four seascapes, three of which were illustrated in the cartoons: *The Battle of the "Kearsarge" and the "Alabama"* (fig. 45), *The "Kearsarge" at Boulogne* (fig. 46), and a work called *Le Steam-Boat (Marine)* (fig. 47). There is some confusion about the latter. The caricaturist, G. Randon,

may have given it the number that properly belonged to catalogue number 40, *Vue de mer, temps calme (Sea View, Calm Weather),* in which a steamboat is a prominent feature and whose dimensions agree with those given in the catalogue. To *Le Steam-Boat (Marine)* Randon added a comic caption—"la vapeur appliqué à la navigation dans un plat d'oseille" (steam-powered navigation in a plate of sorrel purée)—apparently because the astonishingly bright, smooth blue-green hues of Manet's dead-calm sea reminded him of the classic French dish *purée d'oseille.*[11] In recent years catalogue number 34 has been identified with the splendid *Steamboat, Seascape with Porpoises* (see fig. 51), although now that has almost certainly been ruled out, as we will see. *Vue de mer,* with its relatively insignificant steamboat, vanished from sight, perhaps sold by Manet in 1867. When Durand-Ruel acquired it years later, it was given the title *Sortie du port de Boulogne (Leaving Boulogne Harbor,* now called *Steamboat Leaving Boulogne)* (fig. 48),[12] which accurately describes Manet's view of the Folkestone or London packet heading up the Channel and trailing a long wake behind it (fig. 49).

For the calm, unruffled sea of *Steamboat Leaving Boulogne,* with its small ships scattered as far as the distant horizon, Manet selected a finely woven, white-primed linen canvas over which his brush could glide smoothly. The canvas, which has never been lined, is so fine and the pigment has been applied so sparingly that transmitted light enables the picture to be seen through the verso. X-ray examination has confirmed that the sea was painted first and that the boats were added over it. The sea was applied to the canvas almost like a continuous watercolor wash on one of Manet's later sketchbook pages, with the blues sometimes drawn into grays

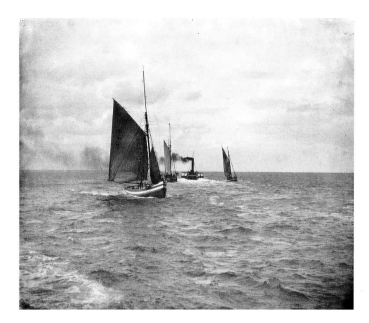

Fig. 49. **CHARLES GRASSIN.** *Bateaux en mer, Boulogne-sur-mer.* Gelatin silver print(?), 19 x 22 ⅝ in. (48.4 x 57.6 cm). Château-Musée de Boulogne-sur-mer

but with no "white horses," no hint of waves— only the salty foam that shows like a rabbit's scut at the back of the steamboat as it churns its way toward Folkestone or takes the longer route to London. In spite of the unnaturally flat surface of the sea, the dispersing clouds of smoke from the steamer indicate a breeze blowing from the southwest. The wind fills the sails of the predominantly gray and black ships and forces the nearby two-masted boat under full sail to keel slightly over to the right, in a manner similar to that of the fishing boat in *The "Kearsarge" at Boulogne.* This is perhaps the most abstract of any of Manet's seascapes, yet it is firmly based on observed reality. The distant smoke-belching steamer moves among graceful sailing boats, placed so that they frame or accompany the packet on its journey. The nearest boats punctuate the canvas in a diagonal sweeping from upper left to lower right through which, on an opposing diagonal, flows the unbroken line of the steamer's wake.

Fig. 50. **ÉDOUARD MANET.** *Steamboat*, 1868. Watercolor, 5 ⅝ x 7 ¼ in. (14.3 x 18.5 cm). Private collection, London

The single-masted cutter on the left, with all sails set, is a trawler trailing its dinghies as it heads back to port; the central boat is a herring-fishing drifter. Although the ships are characterized and particularized, they are little more than ciphers, conjured up in ghostly gray, black, and white on a blue-green sea. Yet their shapes, their relationships to one another, and the movements of Manet's brush as it creates them give us a vivid sense of their movement on the water and of aerial perspective as they recede across the sorrel-bright sea that rises up the canvas, unchanged in intensity, until it meets the luminous, lightly cloudy sky. It is important to know how Manet painted this picture and whether it replicates directly on canvas a view seen from some

such vantage point as the dune de Châtillon overlooking the piers or from the cliffs overlooking the beach. Although the canvas surely was not painted from nature, in the open air, one may ask whether Manet at least painted it in Boulogne, rather than back in his Paris studio. In any event the composition is so knowingly constructed, the color and flatness of the sea are so strikingly unnatural, so *japonisant*, one must conclude that this scene has been reconstructed with considerable artistic license.

We must assume that for *Steamboat Leaving Boulogne* Manet dipped into his sketchbook pages, relying on quick pencil notations of ships and watercolors of sea and sky. This method of working is clearly seen in his use of drawings that served for

later pictures, including those for *Steamboat, Seascape with Porpoises,* which in the past was assumed to date from 1864.[13] *Porpoises,* the title that Durand-Ruel gave the painting when it was shown in London in 1872 and that Manet used when he sold it in 1881 to J. Alden Weir,[14] was based on pages that were detached, before or probably soon after Manet's death, from a sketchbook now preserved in the Louvre and securely dated to 1868, when Manet spent a second, lengthy vacation in Boulogne. On two pages now identified as belonging to the 1868 sketchbook, Manet made graphite drawings of sailing boats, one of a cutter, upright on a single page, and the other showing just the upper half—sails, mast, and pennant—of a sketch that originally extended across two facing pages. On the other sides of these pages Manet made a single watercolored drawing of a steamboat leaving Boulogne (fig. 50). The boat, a side-wheel steamer, is a squat dark shape set against the sea and the sky, whose luminosity contrasts with the clouds of gray smoke belching from the boat's funnel. Light from the sky is reflected in the flattened wake spreading out behind the steamer, which curves out to the left and then down to the foot of the right-hand page. At right a herring boat heads back to harbor. Manet sketched the motifs very lightly in graphite before he applied softly modulated strokes of watercolor, mainly blue-gray, gray-green, and brown; the steamer, in deep blue, is overworked with vigorous "scribbling" in soft graphite that catches the light and creates a vivid sense of the throbbing progress of the mechanized sea monster.[15]

This watercolor is reproduced almost exactly in *Steamboat, Seascape with Porpoises* (fig. 51), but in that canvas Manet "creates a picture" by introducing a large commercial vessel, a two-masted schooner-brig, into the left half of the composition and a more distant fishing boat and a school of porpoises frolicking in the waves at lower right. It is remarkable that the motifs of the two boats in the watercolor occupy only a quarter of the double-page spread in the original sketchbook; the rest is nothing but sea and sky. Although Manet adds more interest to the canvas, he also extends the expanse of sea—onto which the viewer looks down at the lower edge, as if seeing it from a boat or from the end of a pier—thus effectively "raising" the horizon. The sense of a wall of water—a feature of Manet's seascapes that disquieted viewers of the *Battle* at the Salon of 1872—is here increased by the cropping of the sky. The upper limit of the canvas clips the fluttering French flag and the tops of the masts, bringing the boat literally into contact with the picture plane, as is also the case with the advancing fishing boat in the earlier *"Kearsarge" at Boulogne.* The painting is on a noticeably textured linen canvas rather than the smooth, finely woven fabric that Manet preferred. At the left edge the canvas is barely covered by thin washes of green, while pigment was boldly, even roughly applied to the white preparation, particularly on the brig, where a man stands at the helm wearing yellow oilskins; ship and mariner thus both convey a sense of the gritty realities of life and work at sea.

It is disturbing to have to recast this painting as a work of 1868, but the evidence of the preparatory drawing allows no other interpretation. The canvas appears to have such close stylistic links with *The "Kearsarge" at Boulogne,* from four years earlier, that one is led to wonder whether *Porpoises,* whose origins are undocumented, was not painted as a pendant to the earlier work (its provenance is also mysterious until the 1890s). A close con-

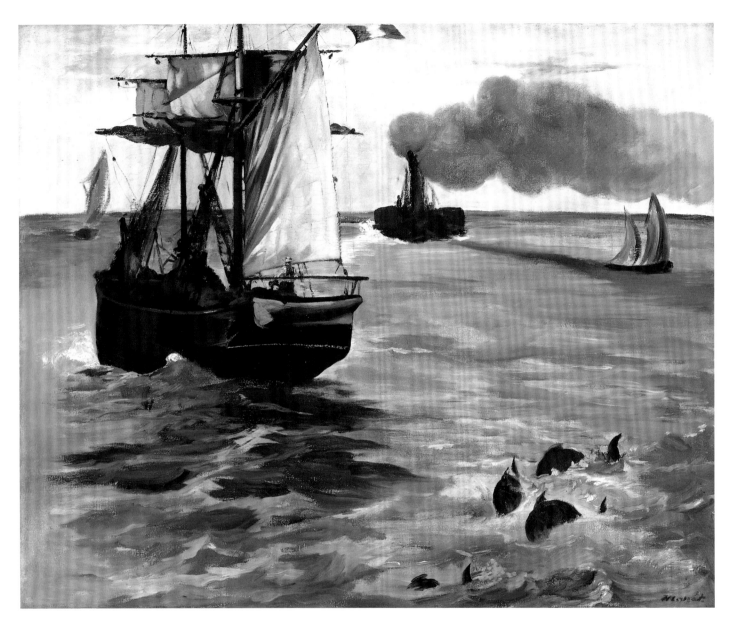

Fig. 51. **ÉDOUARD MANET.** *The Steamboat, Seascape with Porpoises*, ca. 1868. Oil on canvas, 32 1/$_{16}$ x 39 1/$_2$ in. (81.4 x 100.3 cm). Philadelphia Museum of Art, Bequest of Anne Thomson in memory of her father, Frank Thomson, and her mother, Mary Elizabeth Clarke Thomson, 1954 (54.66.3)

Fig. 52. **ÉDOUARD MANET.** *Seascape*, ca. 1868; restrike ca. 1905. Etching, image 4 $\frac{7}{8}$ x 7 $\frac{1}{8}$ in. (12.3 x 18 cm). The Metropolitan Museum of Art, New York, Gift of Mrs. Gustavus S. Wallace, 1932 (32.109.2)

nection between the two is suggested by Manet's only print of a seascape (fig. 52), in which elements found in the two paintings reappear but combined in different ways. Because a print on paper shows the etched design in reverse, it seems clear that Manet copied these motifs directly onto his copperplate: the fishing boat "coming in before the wind" from *The "Kearsarge" at Boulogne,* and the brig and frolicking porpoises from *The Steamboat, Seascape with Porpoises*, although in the etching the brig is under full sail and has lost the dinghy that in the canvas swings from its stern. A date of 1868 or later fits well with the easy, accomplished handling of the etching, which does not seem to have been published in Manet's lifetime.

Although evidence is largely lacking for the paintings related to Manet's stay in Boulogne in 1864,[16] sketches from nature were no doubt the basic elements that enabled the artist to construct his pictures—canvases that would have shocked any professional marine painter worth his salt. Working in the quiet of his studio, Manet inevitably infused the motifs that recorded his own observations in and around Boulogne in 1864 with his experience of other works from earlier traditions of Western art, perhaps also from sources outside those traditions, and from his knowledge of paintings by his own contemporaries. These must also be surveyed if we are to assess the originality of Manet's contribution to marine painting in the 1860s.

NOTES

1. Établissement des Bains, Boulogne-sur-Mer, *Guide-Programme pour la saison de 1864* (Boulogne: Ch. Aigre, 1864).

2. Ibid., p. 3.

3. The house belonged to the recently widowed Madame Florentine Lartizien, a lady of good standing who, like many Boulonnais, rented her home and withdrew to the country for the summer season. For a view of the street and a plan of the house, see Henri Florent, "Manet et Boulogne. 2ᵉ Article Étude sur le milieu boulonnais en 1864. Trois Faits nouveaux," *Les Cahiers du vieux Boulogne*, no. 21 [1984], pp. 8–9.

4. *Bains de mers de Boulougne: Abonnements, 1864.* Archives Municipales, Boulougne-sur-Mer. Léon Leenhoff was not included in the family subscription to the beach club. His own notes, made in or after 1900 for Moreau-Nélaton, state that "we went to Boulogne-sur-mer in 1864." Leenhoff, Notebook 1, p. [69], Département des Estampes, Bibliothèque Nationale de France, Rés–Yb-3-2401–8⁰.

5. From a flyer in English describing the features of the "Sea Bathing Establishment of Boulogne" for 1863 (bound with the *Registre des Abonnements, Saisons 1864–65*, Archives Municipales, Boulogne-sur-Mer). This text is a translation of the document in French bound into the same register, which is repeated in virtually the same terms in the 1864 pocket guide. Établissement des Bains, *Guide-Programme,* p. 5.

6. Établissement des Bains, *Guide-Programme,* p. 7. Merridew's English *Guide* for 1864 reassured visitors that the beach was clean, safe, and pleasant, with "plenty of bathing-machines and attendants...no plunge holes, no rocks or stones, no sharp shells to cut the feet," and that "the Humane Society have boats with life buoys, ropes, and expert swimmers, to assist and protect those in the water." *Merridew's Visitor's Guide to Boulogne-sur-Mer and Its Environs* (London: Simpkin, Marshall and Co., 1864), p. 51.

7. "Quoique je me trouve très bien de mes bains de mer, nos discussions sur le grand art me manquent, et puis il n'y a pas de Café de Bade ici." Édouard Manet, *Manet by Himself: Correspondence and Conversation, Paintings, Pastels, Prints, and Drawings,* ed. Juliet Wilson-Bareau (London: MacDonald & Co., 1991) (French ed., *Manet par lui-même: Correspondence et conversations, peintures, pastels, dessins et estampes* [Paris: Éditions Atlas, 1991]), p. 31. See also Jean-Paul Bouillon, "Les Lettres de Manet à Bracquemond," *Gazette des beaux-arts,* 6th ser., 101 (April 1983), pp. 145–58.

8. Boulogne was heavily bombed during World War II. Rapid rebuilding after the war and a massive offshore development south and west of the piers for industrial uses and harbor facilities have had drastic effects on the landscape.

9. "J'ai déjà fait quelques études de pleine mer avec petits bateaux." *Manet by Himself,* p. 31. See also Bouillon, "Lettres."

10. *Manet by Himself,* p. 32, pl. 10.

11. See Françoise Cachin et al., *Manet, 1832–1883,* exh. cat., Galeries Nationales du Grand Palais, Paris, and The Metropolitan Museum of Art (New York: The Metropolitan Museum of Art, 1983), no. 86. It was not unknown for caricaturists, dashing from one exhibition to another and depicting such massive events as the annual Salon, to confuse their notes and sketches. In Paris in the summer of 1867, for example, there was the major art exhibition at the World's Fair, the Salon, Courbet's large retrospective exhibition, and Manet's smaller one.

12. The provenance of this painting remains incomplete.

13. This method of working is also seen in drawings from a small, mainly watercolored sketchbook that has recently come to light. It is inscribed by Suzanne Manet but had not been catalogued or reproduced until 2001. See Margret Stuffmann, *Von linie und farbe, Franzosische zeichnungen des 19. Jahrhunderts aus der Graphischen Sammlung im Städel und aus Frankfurter Privatbesitz,* exh. cat. (Frankfurt-am-Main: Städelsches Kunstinstitut und Städtisches Galerie, 2001), no. 29, pp. 72–75 (13 pp. shown).

14. Durand-Ruel's fourth (summer) exhibition at 168 New Bond Street, no. 104, *Porpoises;* see Kate Flint, ed., *Impressionists in England: The Critical Reception* (London: Routledge & Kegan Paul, 1984), p. 357, and Manet's account book for 1881, *Les Marsouins Marine* (Leenhoff, Notebook 1, p. [80]). See also Frances Weitzenhoffer, "First Manet Paintings to Enter an American Museum," *Gazette des beaux-arts,* 6th ser., 97 (March 1981), pp. 125–29.

15. Manet used a sketchbook of his favorite type of paper: warm, ivory-toned, with a pronounced pattern of laid lines but a smooth and silky surface. Fragments of a watermark, visible at the foot of both pages, are those of the J WHATMAN mark found in the sketchbook in the Louvre (RF 11.169).

16. A few surviving sketches, on paper with an 1864 watermark, are connected with Manet's earliest attempt to depict the departure of the Folkestone boat, a theme that is the subject of two pictures, both of them extensively reworked. Denis Rouart and Daniel Wildenstein, *Édouard Manet: Catalogue raisonné* (Lausanne: La Bibliothèque des Arts, 1975), vol. 1, nos. 146, 147).

CODA

Sources and Influences

Manet's first seascape, *The Battle of the "Kearsarge" and the "Alabama,"* was constructed in his mind and on canvas from things he had read and seen in the press, from recollections of other art works, and from his memories of the sea. By chance it immediately preceded the Manet family's holiday in Boulogne-sur-Mer in the summer of 1864, when, perhaps as an outgrowth of his recent engagement with the sea as a motif, the artist addressed himself seriously to this subject. The results were several seascapes in which Manet applied much the same principles imagined in the scene of the naval combat to views ostensibly based on direct observation. All are characterized by a high horizon line, usually two-thirds of the way up the canvas, and by an off-center, seemingly haphazard placement on the picture plane of the motifs that make up the pictures.

If one looks for a model for the origins of this apparently very "modern" arrangement in Manet's work, it is not to be found in examples from Dutch seventeenth-century painting, in which seascapes tend to have notably low horizons and a strong perspectival thrust in depth, often expressed by the overlapping of the forms of ships. Nor do Manet's unusual marine compositions follow the French tradition of Vernet or the English school of seascape painters—Turner and Bonington—and their followers in France. These include Courbet, Jongkind, and Boudin, who were all influenced to a greater or lesser degree by the Dutch and English traditions.

A "high horizon" was already a characteristic of Manet's art in 1862, when he piled up the elements of the background bullfight scene in *Mlle V…in the Costume of an Espada* (The Metropolitan Museum of Art, New York), shown at the Salon des Refusés in 1863. He repeated this arrangement to an even more extreme degree in his *Incident in a Bullfight,* which caused a critical outcry at the Salon the following year.[1] One possibly relevant example with respect to Manet's treatment of the sea is Delacroix's striking canvas *Christ Asleep during the Tempest* (fig. 53), which may have been exhibited at 26, boulevard des Italiens in 1860.[2] However, the influence most often cited for the compositional structure and, to some extent, the coloring of Manet's seascapes is that of Japanese prints. In 1854 Japan's ports were first opened for trade with America, followed by a number of European countries, including France and Great Britain. Initial exports to Europe were mostly objects—ceramics, lacquer, bronzes, screens, armor—but as early as 1855 a collection of Japanese color woodcut prints and printed books was bequeathed to the Bibliothèque Impériale in Paris. By 1863 such prints were in demand in France, and in May of that year the poet Charles Baudelaire showed Zacharie Astruc "a

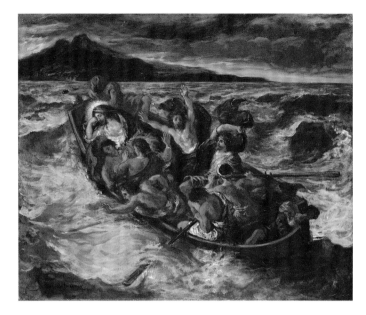

Fig. 53. **EUGÈNE DELACROIX.** *Christ Asleep during the Tempest*, ca. 1853. Oil on canvas, 20 x 24 in. (50.8 x 61 cm). The Metropolitan Museum of Art, New York, H. O. Havemeyer Collection, Bequest of Mrs. H. O. Havemeyer, 1929 (29.100.131)

superb collection of Japanese prints, colored with extraordinary artistry."[3] If Astruc saw these prints—so highly prized by Baudelaire—then Manet—who was close to Baudelaire at that time—almost certainly did too. Manet would have responded to a number of elements in woodcuts by Hokusai and Hiroshige, including the bold simplifications, the clear flat colors, the surprising viewpoints, and the brilliant, shorthand draftsmanship of their lively, energetic figures (figs. 54, 55).

Whistler, too, was swept off his feet by Japanese art and artifacts, at first succumbing to a near bric-a-brac of objects in his works of 1863 to 1864. The clutter was soon penetrated, however, by the refining, simplifying influence of the color print "views" of Hokusai and Hiroshige.[4] Yet Whistler's application of a Japanese aesthetic to his seascapes painted at Trouville in 1865 was tempered by the presence of Courbet and his realist approach to

what he termed *paysages de mer* (seascapes). Even Courbet's most simplified and reductive seascapes are full of almost tangible atmospheric effects. In paintings such as *Marine* (fig. 56) one almost hears the waves breaking. So Whistler, who had wrestled with the sea in a realist vein as early as 1862,[5] found himself caught between two traditions.

In *Trouville (Gray and Green, the Silver Sea)* (fig. 57), one of the most abstract of Whistler's 1865 seascapes, the sea rises to a high, sharply drawn horizon. Muted gray-green washes sweep across the canvas, suggesting the movement of sea and wind but also reminiscent of the patterns created by the grain of the woodblock in the flat or graduated areas of color in Japanese prints. Nothing here really speaks of the sea except the little ships, applied on top of the silvery expanse of water on which they make almost no impact, trailing no wake and with only a hint of water breaking at their bows.[6] The following year Whistler effected a remarkable fusion of the two manners in his *Crepuscule in Flesh Colour and Green: Valparaiso* (fig. 58). Sea and sky are here streaked, grained, and colored to suggest a calm evening. Over the surface tall ships are disposed across the foreground while ominous, low shapes of ironclad battleships lie behind them in the roads off Valparaiso harbor. In the distance to the right, the forest of masts—drawn in graphite over the painted surface—alludes only indirectly to the threat posed to the blockaded Chilean harbor.[7] This remarkably poetic picture, its true subject unknowable since nothing identifies the ships as friend or foe, affords a striking comparison with Manet's *"Kearsarge" at Boulogne* (see fig. 30), in which the ship also remained unidentified—the title in Manet's 1867 retrospective exhibition catalogue makes no refer-

Fig. 54. **UTAGAWA HIROSHIGE.** *Station 32: Arai*, from
Fifty-three Stations of the Tōkaidō, ca. 1842. Polychrome
woodblock print; ink and color on paper, 9 x 13 ⅝ in.
(22.9 x 34.6 cm). The Metropolitan Museum of Art, New
York, Purchase, Joseph Pulitzer Bequest, 1918 (JP568)

Fig. 55. **UTAGAWA HIROSHIGE.** *The Takihi Shrine, Oki
Province*, from *Views of Famous Places in the Sixty-Odd
Provinces*, 1853. Polychrome woodblock print; ink and
color on paper, 14 x 9 ⁷⁄₁₆ in. (35.6 x 24 cm). The
Metropolitan Museum of Art, New York, Purchase,
Joseph Pulitzer Bequest, 1918 (JP589)

Fig. 56. **GUSTAVE COURBET.** *Marine*, 1866. Oil on canvas on gypsum board, 16 ⅞ x 26 in. (43 x 66 cm). Philadelphia
Museum of Art, The John G. Johnson Collection, 1917 (cat. 948)

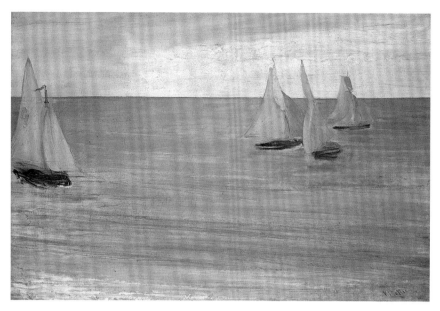

Fig. 57. **JAMES ABBOTT MCNEILL WHISTLER.** *Trouville (Gray and Green, the Silver Sea)*, 1865. Oil on canvas, 20 ¼ x 30 ¼ in. (51.5 x 76.9 cm). The Art Institute of Chicago, Gift of Honoré and Potter Palmer (1922.448)

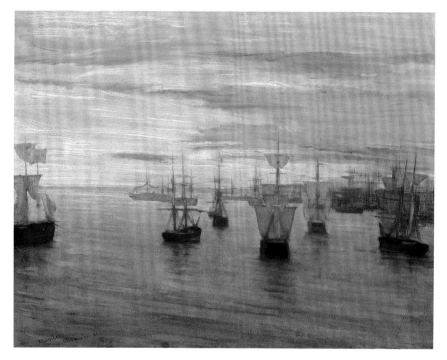

Fig. 58. **JAMES ABBOTT MCNEILL WHISTLER.** *Crepuscule in Flesh Colour and Green: Valparaiso*, 1866. Oil on canvas, 23 ⅛ x 29 ⅞ in. (58.6 x 75.9 cm). Tate, London, Presented by W. Graham Robertson, 1940

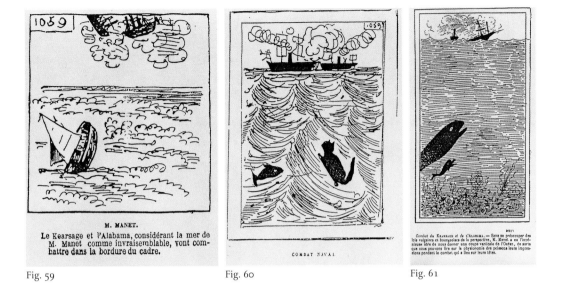

Fig. 59

Fig. 60

Fig. 61

Fig. 59. **CHAM (AMÉDÉE DE NOÉ).** Caricature published in *Le Charivari*, June 2, 1872. "Kearsage [*sic*] and Alabama, considering Mr. Manet's sea implausible, go to battle at the edge of the frame."

Fig. 60. **BERTALL (ALBERT ARNOUX).** Caricature published in *Le Grélot au Salon de 1872.*

Fig. 61. **STOP.** Caricature published in *Le Journal amusant*, May 25, 1872. "Rather than bother with common, bourgeois ideas about [rendering] perspective, Mr. Manet had the ingenious idea of giving us a cross section of the ocean, so that we can read in the facial expressions of the fish their impressions of the battle that took place overhead."

ence to *Kearsarge.* But instead of a poetic title for a pictorial "tone poem," as in Whistler's *Crepuscule,* Manet chose to foreground the very local, particularized feature of the "fishing boat coming in before the wind."

Although Manet was without a doubt sympathetic to the striking qualities of Japanese prints and found in them much to exploit in purely visual terms, his *japonisme* in 1864 seems fainthearted when compared with his interest in the material realities of his marine subject matter. Other, more strongly embedded influences were also in play at this early date. As already observed, the compositional structure of Manet's early seascapes is not far removed from that of his early Salon compositions, such as *Mlle V...in the Costume of an Espada* and *Incident in a Bullfight.* In

these works, despite their homage to Spanish themes and their literal use of such Spanish motifs as Goya's prints, the overwhelming influence was still that of the Italian Renaissance. It may seem a long way from the frescoes of Benozzo Gozzoli and Ghirlandaio or those of Andrea del Sarto, which Manet copied in Italy in 1857,[8] to his 1864 seascapes, but the distribution of motifs that rise up the picture plane without overlapping (derived from the conventions of storytelling in Gothic art) is found in both types of image. The remarkable expanse of water in *The Battle of the "Kearsarge" and the "Alabama"* provided caricaturists at the Salon of 1872—from Cham to Stop and Bertall (figs. 59–61)—with a topic for their humorous drawings and commentary. A comparison, if not a "source," for what the

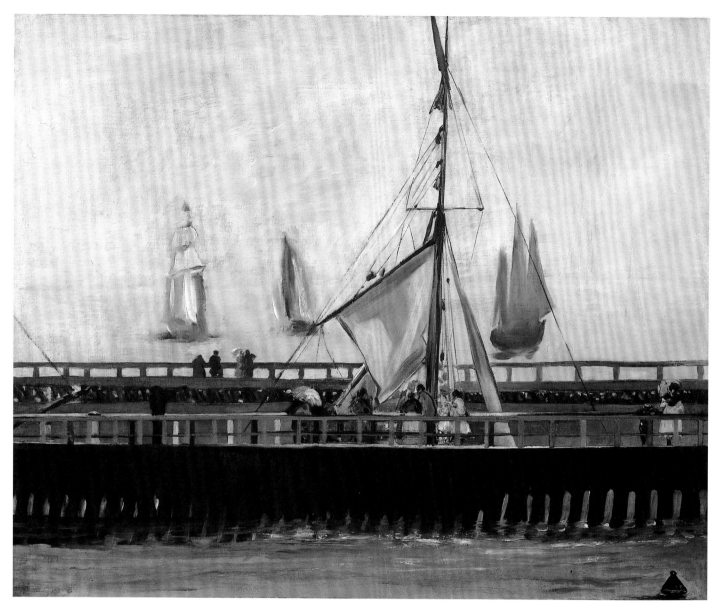

Fig. 62. **ÉDOUARD MANET.** *The Jetty of Boulogne-sur-Mer,* 1868. Oil on canvas, 23 3/8 x 28 7/8 in. (59.5 x 73.3 cm). Van Gogh Museum, Amsterdam (inv. no. S507S/2002)

Salon caricatures depicted as Manet's "cross section" of the sea has even been traced to a popular book on fishes, reptiles, and seabirds, in which the greater spotted dogfish is seen both above and below the waves, emerging from the watery depths, while tiny boats are visible on the distant horizon.[9]

The outstanding novelty and strength of Manet's early seascapes derive from the fact that the various underlying influences—including his admiration for the straightforward clarity and energy of pictures by such Dutch marine painters as Ludolf Backhuysen (see fig. 28)—were filtered through and remained subservient to his own direct experience of the sea and ships, whether remembered from his early ocean voyage or sketched firsthand in Boulogne-sur-Mer. The two paintings indisputably painted as a result of his 1864 visit to

Boulogne were followed by many more that relate to his second recorded visit, in 1868. In these the Japanese influence is much stronger. Pictures of the twin piers at Boulogne (fig. 62), of ships at sea (fig. 63), and of holidaymakers on the beach or bathing can be compared with Japanese prints like Hokusai's famous view of Mount Fuji from a terrace, woodcut views by Hiroshige (see figs. 54, 55), and triptychs by such artists as Kunisada. One of the largest and most revealing collections of Japanese prints was formed over many years by Claude Monet, and many of the prints in his collection are relevant to Manet's interest in such works.[10]

Monet came the closest of any artist to Manet's pictorial language in his seascapes, and he may even have influenced him to some degree. Manet owned or intervened in the sale of several of Monet's seascapes, actively and generously supporting his younger colleague during the difficult years of the 1870s.[11] He admired Monet's seascapes unreservedly and, according to Manet's friend Antonin Proust, called Monet "the Raphael of water." At his death Manet owned several paintings by Monet, one of which was a splendid *Boat Lying at Low Tide at Fécamp* (1868, private collection).[12] Given the uncertain chronology of both artists' work and of the exhibition history of relevant paintings, it is difficult to determine the extent to which one artist was indebted to the other. It is generally agreed that Monet must have seen Manet's *Battle,* and possibly also *The "Kearsarge" at Boulogne,* before painting his *Green Wave (Vague verte)* (fig. 64), but there is no consensus about the date of Monet's painting, which the artist himself misdated to 1865. It is possible that he did not execute it until 1866—when Manet's paintings may or may not have been shown at Martinet's spring exhibition—or even until May 1867, when Manet included both paint-

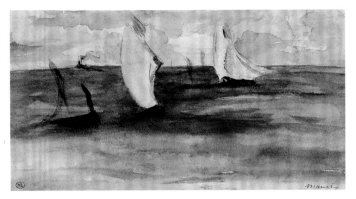

Fig. 63. **ÉDOUARD MANET.** *Seascape with Sailing Ships,* 1864–68. Watercolor, 4 ³/₈ x 8 ¹/₄ in. (11 x 21 cm). Musée du Louvre, Paris (R.F. 31.283)

ings in his retrospective exhibition that opened near the Pont de l'Alma.

Conversely, two Monet paintings— *Mouth of the Seine at Honfleur (L'Embouchure de la Seine à Honfleur)* (1865, Norton Simon Museum, Pasadena) and *La Pointe de la Hève at Low Tide (Pointe de la Hève à marée basse)* (1865, Kimbell Art Museum, Fort Worth) were very well received at the Salon of 1865, when Manet was castigated for *Olympia* (1863, Musée d'Orsay, Paris) and *Jesus Mocked by the Soldiers* (1864–65, The Art Institute of Chicago). Moreover, with only a vowel distinguishing the two artists' names, Monet's seascapes were mistaken for works by Manet, who believed that some joke had been played on him and whose discomfiture Manet recounted years later.[13] After this initial misunderstanding was cleared up, Manet became convinced of Monet's uniquely individual talent, and the clarity and luminosity of the younger artist's response to marine subjects may well have encouraged Manet to abandon the relatively somber "studio" tones of his painting in the early 1860s. One would like in particular to be able to date Manet's application of more brilliant greens to the sea in *The Battle of the "Kearsarge" and the "Alabama."* If it was done before the painting was exhibited

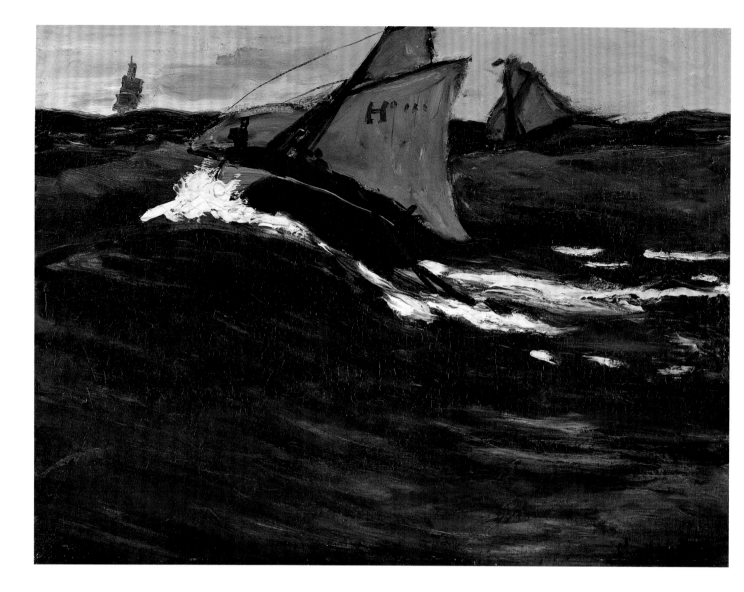

in 1867, Monet may have lightened and heightened his own palette in response; if the contrary, then Manet would have been following the example that Monet had set in such paintings as *The Beach at Sainte-Adresse (La Plage de Sainte-Adresse)* (1867, The Art Institute of Chicago) and *Regatta at Sainte-Adresse (Les Régates à Sainte-Adresse)* (1867, The Metropolitan Museum of Art, New York).[14] Manet's engagement with the *Battle, The "Kearsarge" at Boulogne,* and his subsequent seascapes, together with Monet's fresh approach to marine painting in the mid- to

Fig. 64. **CLAUDE MONET.** *The Green Wave,* ca. 1866–67. Oil on canvas, 19 ¹⁄₈ x 25 ¹⁄₂ in. (48.6 x 64.8 cm). The Metropolitan Museum of Art, New York, H. O. Havemeyer Collection, Bequest of Mrs. H. O. Havemeyer, 1929 (29.100.111)

later 1860s, paved the way for a new kind of painting. A naval battle scene and the portrait of the victorious ship became the advance guard of radical developments that led to what we have come to know as Impressionism.

1. Anne Coffin Hanson long ago drew attention to this aspect of Manet's art in the early 1860s, particularly the characteristics of his seascapes. See Anne Coffin Hanson, "A Group of Marine Paintings by Manet," *Art Bulletin* 44 (December 1962), pp. 332–36. For reconstructions of the *Incident in a Bullfight,* see Susan Grace Galassi, *Manet's "The Dead Toreador" and "The Bullfight": Fragments of a Lost Salon Painting Reunited,* exh. cat. (New York: The Frick Collection, 1999).

2. See Alice Cooney Frelinghuysen et al., *Splendid Legacy: The Havemeyer Collection,* exh. cat. (New York: The Metropolitan Museum of Art, 1993), no. 261. A picture in the 1864 Delacroix exhibition in Paris is less likely to have been an influence on the seascapes because it did not take place until the end of the year.

3. For the availability and influence of Japanese art in France and England, see the "Chronology" by Geneviève Lacambre in *Le Japonisme,* exh. cat., Galeries Nationales du Grand Palais, Paris, and National Museum of Western Art, Tokyo (Paris: Éditions de la Réunion des Musées Nationaux, 1988), p. 60 ff.

4. See Richard Dorment and Margaret F. MacDonald, *James McNeill Whistler,* exh. cat., Tate Gallery; Musée d'Orsay, Paris; and National Gallery of Art, Washington, D.C. (London: Tate Gallery Publications, 1994), pp. 85–88, 111–19; Gary Tinterow and Henri Loyrette, *Origins of Impressionism,* exh. cat., Galeries Nationales du Grand Palais, Paris, and The Metropolitan Museum of Art (New York: The Metropolitan Museum of Art, 1994), pp. 233–41.

5. See Tinterow and Loyrette, *Origins,* p. 240.

6. In comparison, Manet's *Steamboat Leaving Boulogne* (fig. 48) reveals a convincing grasp of what the ships are doing in spite of their simplified form and the arbitrary structure of the composition.

7. See Dorment and MacDonald, *Whistler,* pp. 115–18.

8. See Peter Meller, "Manet in Italy: Some Newly Identified Sources for His Early Sketchbooks," *Burlington Magazine* 144 (February 2002), pp. 68–110.

9. Louis Figuier, *Les Poissons, les reptiles et les oiseaux* (Paris: Hachette, 1868), p. 28, fig. 16, *Grande Roussette,* wood engraving by A. Mesnel. Although this ingenious suggestion is not supported by the date of the work (and it is the only engraving in the book to show such a view), it is possible that similar, quasi-scientific depictions had some bearing on Manet's visualization of the combat with *Alabama* sinking below the waves.

10. *The Sazaido of the Gohyaku Rakan-ji Temple,* from *The Thirty-Six Views of Mount Fuji* by Katsushika Hokusai, prints by Utagawa Hiroshige from several of his series of views, triptychs of beach scenes with awabi fishers; see Geneviève Aitken and Marianne Delafond, *La Collection d'estampes japonaises de Claude Monet à Giverny* (Giverny: Maison de Monet, 1983), nos. 59, 97, 98, 126, 130.

11. Antonin Proust, "Edouard Manet: Souvenirs," *La Revue blanche* 12 (March 1, 1897), p. 203. For the Monet paintings owned by or in some way related to Manet, see Daniel Wildenstein, *Claude Monet: Biographie et catalogue raisonné,* vol. 1 (Lausanne and Paris: La Bibliothèque des Arts, 1974), p. 457, "Index des noms propres figurant à l'historique des tableaux," under "Manet (Édouard)."

12. Wildenstein, *Monet,* no. 117.

13. See Thiébault-Sisson, "Claude Monet: Les Années d'épreuves," *Le Temps,* November 26, 1900; see also Étienne Moreau-Nélaton, *Manet raconté par lui-même,* 2 vols. (Paris: Henri Laurens, 1926), vol. 1, p. 91, which attributes different words to Manet and gives no source.

14. See Wildenstein, *Monet,* nos. 91, 92; Tinterow and Loyrette, *Origins,* p. 66, figs. 87, 88.

WORKS IN THE EXHIBITION

Height precedes width precedes depth. References to the Manet catalogue raisonné by Denis Rouart and Daniel Wildenstein, vol. I: *Paintings,* and vol. II: *Pastels, Watercolors, and Drawings* (see Selected Bibliography, p. 85) are abbreviated as RW 1975. Works by Manet are in chronological order as established by recent scholarship (see "Manet's 1864 Boulogne Seascapes," in this catalogue).

WORKS BY ÉDOUARD MANET *(French, 1832–1883)*

The Battle of the "Kearsarge" and the "Alabama," 1864. Oil on canvas, 52 $^3/_4$ x 50 in. (134 x 127 cm). Philadelphia Museum of Art, The John G. Johnson Collection, 1917 (cat. 1027)
RW 1975 I, 76

The "Kearsarge" at Boulogne, 1864. Watercolor, 10 x 13 $^1/_4$ in. (25.5 x 33.5 cm). Musée des Beaux-Arts, Dijon (2959E)
RW 1975 II, 223

The "Kearsarge" at Boulogne, 1864. Oil on canvas, 32 $^1/_8$ x 39 $^3/_8$ in. (81.6 x 100 cm). The Metropolitan Museum of Art, New York, Partial and Promised Gift of Peter H. B. Frelinghuysen, and Purchase, Mr. and Mrs. Richard J. Bernhard Gift, by exchange, Gifts of Mr. and Mrs. Richard Rodgers and Joanne Toor Cummings, by exchange, and Drue Heinz Trust, The Dillon Fund, The Vincent Astor Foundation, Mr. and Mrs. Henry R. Kravis, The Charles Engelhard Foundation, and Florence and Herbert Irving Gifts, 1999 (1999.442)
RW 1975 I, 75

Steamboat Leaving Boulogne, 1864. Oil on canvas, 29 x 36 $^1/_2$ in. (73.6 x 92.6 cm). The Art Institute of Chicago, Potter Palmer Collection (1922.425)
RW 1975 I, 78

Seascape with Sailing Ships, 1864–68. Watercolor, 4 $^3/_8$ x 8 $^1/_4$ in. (11 x 21 cm). Cabinet des dessins, Musée du Louvre, Paris (R.F. 31.283)
RW 1975 II, 224

Sailing Ships at Sea, 1864–68. Oil on canvas, 13 $^3/_8$ x 22 in. (34 x 55.8 cm). The Cleveland Museum of Art, Purchase from the J. H. Wade Fund (1940.534)
RW 1975 I, 197

Steamboat, 1868. Graphite and watercolor, 5 $^5/_8$ x 7 $^1/_4$ in. (14.3 x 18.5 cm). Private collection, London
RW 1975 II, 222

The Steamboat, Seascape with Porpoises, ca. 1868. Oil on canvas, 32 $^1/_{16}$ x 39 $^1/_2$ in. (81.4 x 100.3 cm). Philadelphia Museum of Art, Bequest of Anne Thomson in memory of her father, Frank Thomson, and her mother, Mary Elizabeth Clarke Thomson, 1954 (54.66.3)
RW 1975 I, 79

Seascape, ca. 1868; restrike ca. 1905. Etching, image 4 $^7/_8$ x 7 $^1/_8$ in. (12.3 x 18 cm). The Metropolitan Museum of Art, New York, Gift of Mrs. Gustavus S. Wallace, 1932 (32.109.2)

The Jetty of Boulogne-sur-Mer, 1868. Oil on canvas, 23 $^3/_8$ x 28 $^7/_8$ in. (59.5 x 73.3 cm). Van Gogh Museum, Amsterdam (inv. no. S507S/2002)
RW 1975 I, 145

WORKS BY OTHER ARTISTS

PAINTINGS

GUSTAVE COURBET *(French, 1819–1877)*

> *Marine*, 1866. Oil on canvas on gypsum board, 16 $^7/_8$ x 26 in. (43 x 66 cm). Philadelphia Museum of Art, The John G. Johnson Collection, 1917 (cat. 948)

HENRI DURAND-BRAGER *(French, 1814–1879)*

> *Battle between U.S.S. "Kearsarge" and C.S.S. "Alabama,"* 1864. Oil on canvas, 40 x 64 in. (101.6 x 162.6 cm). Union League Club of New York

CLAUDE MONET *(French, 1840–1926)*

> *The Green Wave*, ca. 1866–67. Oil on canvas, 19 $^1/_8$ x 25 $^1/_2$ in. (48.6 x 64.8 cm). The Metropolitan Museum of Art, New York, H. O. Havemeyer Collection, Bequest of Mrs. H. O. Havemeyer, 1929 (29.100.111)

JAMES ABBOTT MCNEILL WHISTLER *(American, 1834–1903)*

> *Trouville (Gray and Green, the Silver Sea)*, 1865. Oil on canvas, 20 $^1/_4$ x 30 $^1/_4$ in. (51.5 x 76.9 cm). The Art Institute of Chicago, Gift of Honoré and Potter Palmer (1922.448)

> *Crepuscule in Flesh Colour and Green: Valparaiso*, 1866. Oil on canvas, 23 $^1/_8$ x 29 $^7/_8$ in. (58.6 x 75.9 cm). Tate, London, Presented by W. Graham Robertson, 1940

PRINTS

LÉON-AUGUSTE ASSELINEAU *(French, 1808–1889)*

> *Vue des bains, prise de la jetée de l'est à Boulogne-sur-mer*, ca. 1858–63. Color lithograph, 17 $^1/_2$ x 22 $^7/_{16}$ in. (44.5 x 57 cm) framed. Bibliothèque Nationale de France, Paris

CURRIER & IVES, PUBLISHER

> *The U.S. Sloop of War "Kearsarge" 7 Guns, Sinking the Pirate "Alabama" 8 Guns: Off Cherbourg, France, Sunday, June 19th, 1864*, 1864. Hand-colored lithograph, 16 x 22 in. (40.6 x 55.9 cm). Museum of the City of New York, The Harry T. Peters Collection (56.300.435)

UTAGAWA HIROSHIGE *(Japanese, 1797–1858)*

> *Station 32: Arai*, from *Fifty-three Stations of the Tōkaidō*, Edo period (1615–1868), ca. 1842. Polychrome woodblock print; ink and color on paper, 9 x 13 $^5/_8$ in. (22.9 x 34.6 cm). The Metropolitan Museum of Art, New York, Purchase, Joseph Pulitzer Bequest, 1918 (JP568)

> *The Takihi Shrine, Oki Province*, from *Views of Famous Places in the Sixty-Odd Provinces*, Edo period (1615–1868), 1853. Polychrome woodblock print; ink and color on paper, 14 x 9 $^7/_{16}$ in. (35.6 x 24 cm). The Metropolitan Museum of Art, New York, Purchase, Joseph Pulitzer Bequest, 1918 (JP589)

CHARLES LONGUEVILLE *(French, 1829–after 1882)*

> *Combat naval (L'Alabama coulant sous le feu de Kearsage* [sic], n.d. Etching; image 8 $^5/_8$ x 11 $^7/_8$ in. (22 x 30.3 cm). The Metropolitan Museum of Art, New York, Gift of William H. Huntington, 1883 (83.2.954)

AFTER WARREN SHEPPARD *(British, 1858–1937)*

> *Sinking of the Alabama*, 1897. Commercial lithograph; image 4 $^1/_2$ x 7 in. (11.4 x 17.8 cm). Published by the Woolfall Company, New York, for the *People's Standard History of the United States*. The Metropolitan Museum of Art, New York, Gift of Joseph Verner Reed, 1964 (64.542.205)

PHOTOGRAPHS

ÉDOUARD BALDUS *(French, born Prussia, 1813–1889)*

Entrée du Port de Boulogne (Boulogne: The Port Entrance), 1855. Salted paper print from paper negative, 11 $^5/_{16}$ x 17 $^1/_8$ in. (28.8 x 43.5 cm). The Metropolitan Museum of Art, New York, Louis V. Bell Fund, 1992 (1992.5000)

FRANÇOIS SÉBASTIEN RONDIN

(French, active 1860s-early 1870s)

Canon de l'avant du Kearsarge, 1864. Albumen silver print from glass negative, image 2 $^5/_{16}$ x 3 $^{11}/_{16}$ in. (5.8 x 9.3 cm); card 2 $^{11}/_{16}$ x 4 $^3/_{16}$ in. (6.8 cm x 10.5 cm). Private collection, London

Combat naval en vue de Cherbourg, 1864. Albumen silver print from glass negative, image 2 $^1/_4$ x 3 $^3/_4$ in. (5.7 x 9.5 cm); card 2 $^5/_8$ x 4 $^3/_{16}$ in. (6.7 x 10.5 cm). Manuscript Division, Library of Congress, Washington, D.C.

Équipage du Kearsarge, poste de combat, 1864. Albumen silver print from glass negative, image 2 $^1/_4$ x 3 $^5/_8$ in. (5.7 x 9.2 cm); card 2 $^3/_4$ x 4 $^3/_{16}$ in. (7 x 10.5 cm). Manuscript Division, Library of Congress, Washington, D.C.

Le Kearsarge, 1864. Albumen silver print from glass negative, image 2 $^5/_8$ x 3 $^3/_4$ in. (6.7 x 9.5 cm); card 2 $^3/_4$ x 4 $^3/_{16}$ in. (7 x 10.5 cm). Manuscript Division, Library of Congress, Washington, D.C.

Mosaïque du Kearsarge, 1864. Albumen silver print from glass negative, image 3 $^3/_4$ x 2 $^1/_4$ in. (9.5 x 5.7 cm); card 4 $^3/_{16}$ x 2 $^5/_8$ in. (10.5 x 6.7 cm). Manuscript Division, Library of Congress, Washington, D.C.

Officers on the Deck of U.S.S. "Kearsarge," 1864. Albumen silver print from glass negative, image 6 $^1/_8$ x 8 $^3/_8$ in. (15.6 x 21.2 cm). The Metropolitan Museum of Art, New York, Funds from various donors, 2003 (2003.113)

Combat naval entre le Kearsarge et l'Alabama (photograph of an unknown painting), 1864. Albumen silver print from glass negative, image 2 $^1/_4$ x 3 $^7/_8$ in. (5.8 x 9.9 cm); card 2 $^3/_4$ x 4 $^1/_8$ in. (7 x 10.6 cm). Private collection, London

UNKNOWN ARTIST

Le Port de Boulogne (The Port of Boulogne), ca. 1850–53. Salted paper print (Blanquart-Évrard Process) from paper negative, 6 $^1/_4$ x 9 $^1/_{16}$ in. (15.9 x 23 cm). The Metropolitan Museum of Art, New York, Harris Brisbane Dick Fund, 1946 (46.122.12)

Digue (branche Est). Vue prise du fort central. Albumen silver print, 13 x 10 in. (33 x 25.5 cm). Service Historique de la Marine, Cherbourg

Passe Ouest de la rade. Fort Chavaignac [sic]. Albumen silver print, 13 $^3/_8$ x 10 $^5/_8$ in. (34 x 27 cm). Service Historique de la Marine, Cherbourg

OTHER WORKS

Illustrated London News, June 25, 1864, p. 625. Newspaper bound into book format, 15 $^7/_8$ x 11 $^1/_4$ in. (40.3 x 28.6 cm). General Research Division, The New York Public Library, Astor, Lenox and Tilden Foundations

Letter from Édouard Manet to Philippe Burty, undated (ca. July 18, 1864). Written from Boulogne-sur-Mer. Bibliothèque d'Art et d'Archéologie, Fondation Jacques Doucet, Paris (carton 59, doc. 37361/37362)

Letter from John Ancrum Winslow to Benjamin Moran, July 7, 1864. Private collection, London

Log of U.S.S. *Kearsarge,* vol. 3 (February 27–November 26, 1864), 17 x 11 $^1/_2$ x 2 in. (43.2 x 29.2 x 5.1 cm) closed. National Archives, Washington, D.C.

Hand-drawn map of the courses sailed by U.S.S. *Kearsarge* and C.S.S. *Alabama* on June 19, 1864, by John Ancrum Winslow. Brown and blue ink on tracing paper, 17 $^3/_4$ x 12 in. (45.1 x 30.5 cm). National Archives, Washington, D.C.

Model of U.S.S. *Kearsarge,* constructed by Dr. Arthur C. Roberts, 1992–97. Wood (basswood, holly, and other woods), metal, and other assorted materials. 24 x 50 $^1/_2$ x 12 $^3/_4$ in. (61 x 128.3 x 32.4 cm); scale $^3/_{16}$ in.: 1 ft. Maine Maritime Museum, Bath (MMM98.069)

SELECTED BIBLIOGRAPHY

Bazire, Edmond. *Manet.* Paris: A. Quantin, 1884.

Cachin, Françoise, et al. *Manet, 1832–1883.* Exh. cat. Galeries Nationales du Grand Palais, Paris, and The Metropolitan Museum of Art. New York: The Metropolitan Museum of Art, 1983.

Canney, Donald L. *Lincoln's Navy: The Ships, Men, and Organization, 1861–65.* Annapolis: Naval Institute Press, 1998.

————. *The Old Steam Navy.* Vol. 1, *Frigates, Sloops, and Gunboats, 1815–1885.* Annapolis: Naval Institute Press, 1990.

Catalogue des tableaux de M. Édouard Manet exposés avenue de l'Alma en 1867. Exh. cat. Paris, 1867.

Darragon, Eric. *Manet.* Paris: Fayard, 1989.

Ellicott, John M. *The Life of John Ancrum Winslow, Rear-Admiral, United States Navy, Who Commanded the U.S. Steamer "Kearsarge" in Her Action with the Confederate Cruiser "Alabama."* 2nd ed. New York: G. P. Putnam's Sons, 1905.

Hanson, Anne Coffin. "A Group of Marine Paintings by Manet." *Art Bulletin* 44 (December 1962), pp. 332–36.

————. *Manet and the Modern Tradition.* New Haven and London: Yale University Press, 1977.

Manet, Édouard. *Lettres de jeunesse, 1848–1849: Voyage à Rio.* Paris: Louis Rouart et Fils, 1928.

————. *Manet by Himself: Correspondence and Conversation, Paintings, Pastels, Prints, and Drawings.* Ed. Juliet Wilson-Bareau. London: MacDonald & Co., 1991. French ed., *Manet par lui-même: Correspondence et conversations, peintures, pastels, dessins et estampes.* Paris: Éditions Atlas, 1991.

Moreau-Nélaton, Étienne. *Manet raconté par lui-même.* 2 vols. Paris: Henri Laurens, 1926.

Proust, Antonin. "Edouard Manet: Souvenirs." *La Revue blanche* 12 (February 15, March 1 and 15, 1897), pp. 168–80, 201–7, 306–15.

————. *Édouard Manet: Souvenirs.* Ed. Auguste Barthélemy. Paris: Henri Laurens, 1913.

Rouart, Denis, and Daniel Wildenstein. *Édouard Manet: Catalogue raisonné.* 2 vols. Lausanne: La Bibliothèque des Arts, 1975.

Scharf, J. Thomas. *History of the Confederate States Navy from Its Organization to the Surrender of Its Last Vessel.* 2nd ed. Albany, N.Y.: Joseph McDonough, 1894.

Semmes, Raphael. *Memoirs of Service Afloat, during the War between the States.* Baltimore: Kelly, Piet & Co., 1869.

————. *Service Afloat and Ashore during the Mexican War.* Cincinnati: Wm. H. Moore & Co., 1851.

Spencer, Warren F. *The Confederate Navy in Europe.* University, Ala.: University of Alabama Press, 1983.

Tinterow, Gary, and Geneviève Lacambre. *Manet/Velázquez: The French Taste for Spanish Painting.* Exh. cat. Musée d'Orsay, Paris, and The Metropolitan Museum of Art. New York: The Metropolitan Museum of Art; New Haven: Yale University Press, 2003.

PHOTOGRAPH CREDITS